ANIMALS
A PICTURE SOURCEBOOK
EDITED AND ARRANGED BY DON RICE

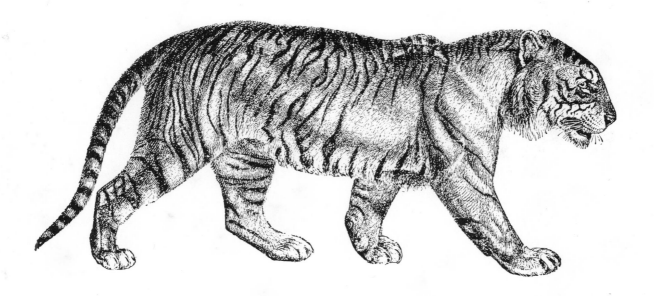

Over 700 copyright-free illustrations for direct copying and reference.

VNR VAN NOSTRAND REINHOLD COMPANY
New York Cincinnati Toronto London Melbourne

Published in 1979 by Van Nostrand Reinhold Company
A division of Litton Educational Publishing, Inc.
135 West 50th Street, New York, NY 10020, U.S.A.

Van Nostrand Reinhold Limited
1410 Birchmount Road
Scarborough, Ontario M1P 2E7, Canada

Van Nostrand Reinhold Australia Pty. Ltd.
17 Queen Street
Mitcham, Victoria 3132, Australia

Van Nostrand Reinhold Company Limited
Molly Millars Lane
Wokingham, Berkshire, England

16 15 14 13 12 11 10 9 8 7 6 5 4 3

Library of Congress Cataloging in Publication Data

Main entry under title:

Animals, a picture sourcebook.

 Includes index.
 1. Animals in art. 2. Illustration of books.
I. Rice, Donald L.
NC961.7.A54A54 760 79-12871
ISBN 0-442-26102-0

Introduction

The illustrations in this bestiary were drawn or engraved over a period of 100 years, from the early 1800s to the early 1900s, by innumerable artists with a wide variety of skills, styles, and knowledge about their subjects. Many are beautifully executed and very accurate. Some, such as the ferocious dolphins and smiling orangutan, are quite fanciful. All have useful applications for artists, students, and researchers. The collection is intended to serve as three books in one:

Clip Book

Up to 10 illustrations may be copied directly for each graphic arts project without obtaining further permission from the publisher. A credit line, though not necessary, would be appreciated.

Source Book

As a portable artist's "swipe file" it will provide a handy guide in the creation of original drawings and paintings of animals.

Reference Book

The animals pictured are alphabetically categorized first by order (indicated by a solid black line), then by family (broken line), and then species (with occasional lapses in alphabetizing to accommodate page layouts). It seemed unnecessary for the purposes of this book to divide the families into genera. Similarly suborders, superfamilies, and the like have been disregarded with one exception: the division of the order *Cetacea* into the suborders *Mystacoceti* and *Odontoceti*.

Mammals were not systematically classified to any reasonable degree until Linnaeus published the 10th edition of his *Systema Naturae* in 1785. Since that time there have been radical changes in the approaches to scientific classification. Revisions are still being made. It is highly probable that some readers will disagree with the inclusion of certain species within certain families, e.g., the giant panda has been at times classified as both a member of the *Ursidae* family (bears) and the *Procyonidae* (raccoons). In this book it is included with the bears. There are other possible areas of disagreement. Seals and walruses, for example, have been considered as both a suborder under *Carnivora* and as a separate order unto themselves. I have treated them as an order (*Pinnipedia*).

Readers may also find some out-and-out mistakes. They are encouraged to bring these to my attention by writing to the publisher.

Don Rice

Contents

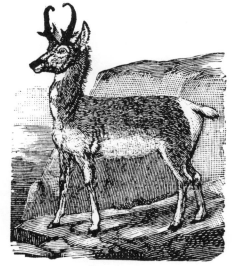

Pronghorn

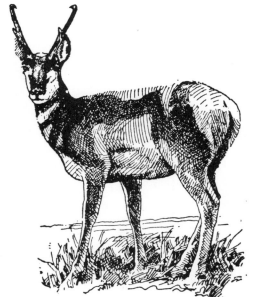

Pronghorn

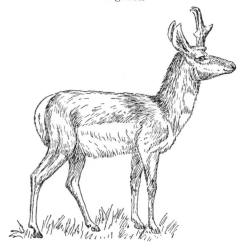

Pronghorn

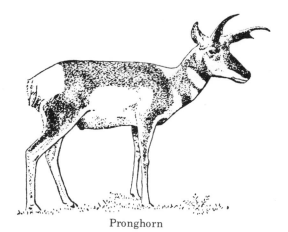

Pronghorn

Bovidae

Addax

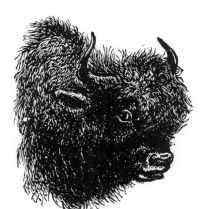

Aurochs

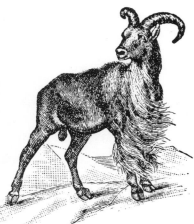

Aoudad

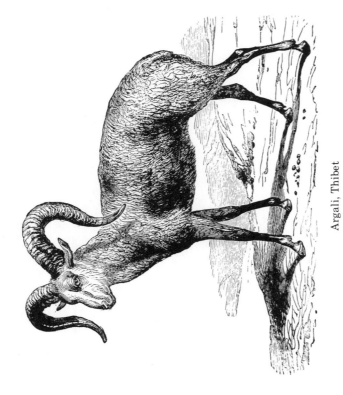

Argali, Thibet

Bighorn Sheep

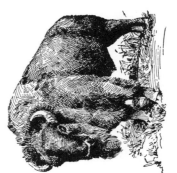

Bison

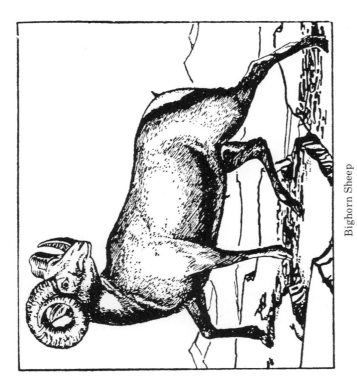

Bighorn Sheep

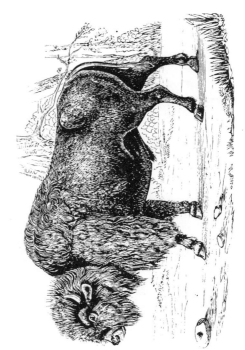

Bison

Bison

Bison

Bison

Blackbuck

Blesbok

Bluebuck

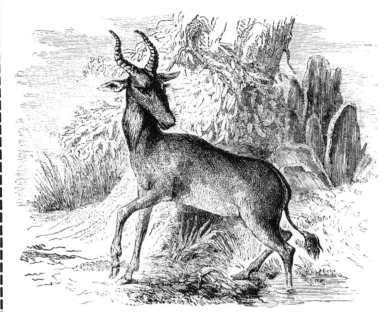

Bubale

Bushbuck

Cambing-utan

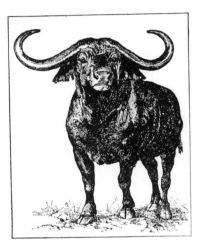

Cape Buffalo

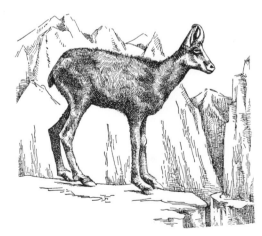

Chamois

Chamois

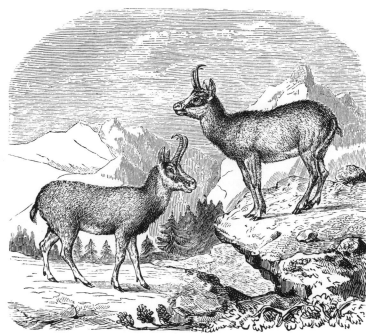

Chamois

Chamois

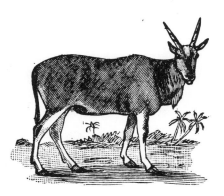

Eland

Duykerbok

Eland

Forest Ox

Cows and Calf

Bull

Cow

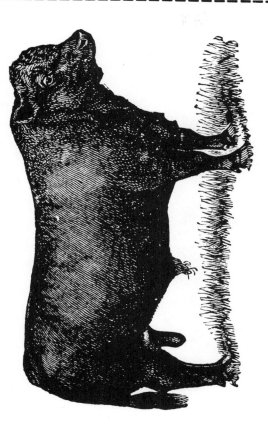

Aberdeen Angus

Ayershire

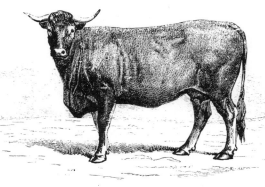

Cow of Bazadois

Cow of Bearn

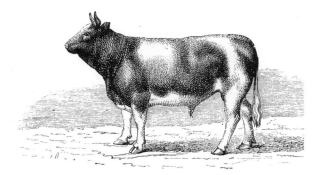

Breton Bull

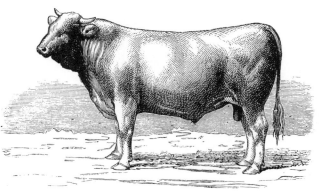

Charolaise Bull

Devon Bull

Durham Polled Cow

Dutch Belted Bull

Galloway Bull

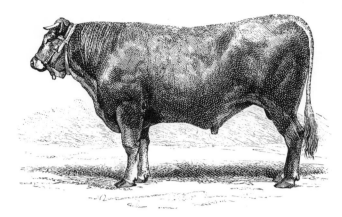

Bull of La Garonne

Guernsey Cow

Hereford Steer

Hereford Bull

Holstein-Friesian Cow

Jersey Cow

Norman Bull

Red Polled Cow

Shorthorn Bull

Sussex Steer

Swiss Cow

Texas Longhorn Steer

West Highland Cow

11

Four-horned Antelope

Gaur

Gazelle

Gazelle

Gnu

Brindled Gnu

Gnu

Gnu

Gnu

Hartebeest

Ibex

Ibex

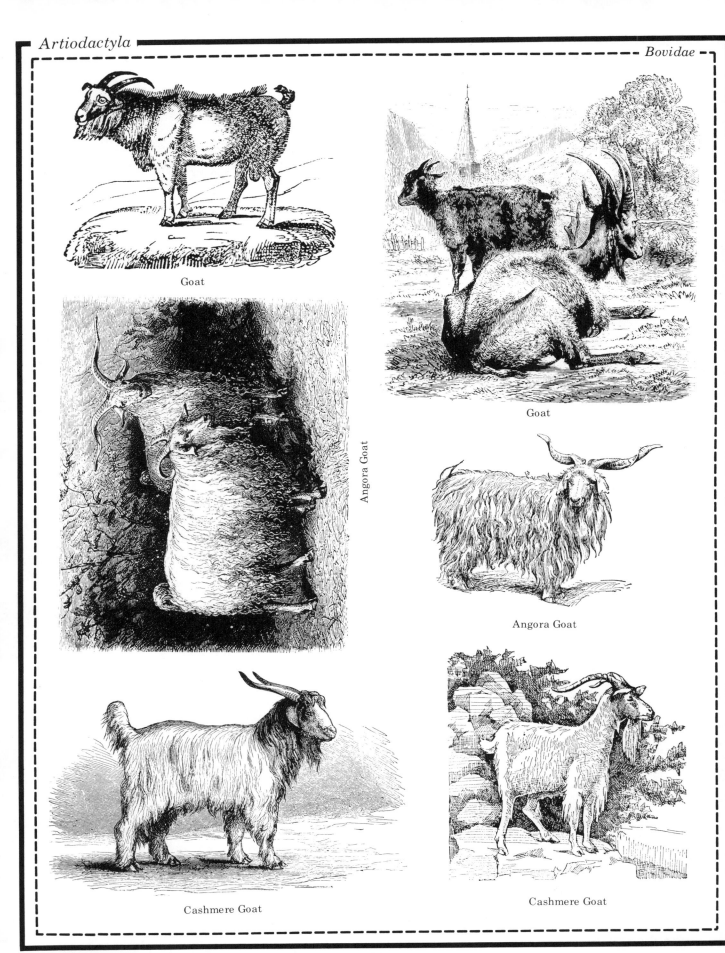

Goat

Goat

Angora Goat

Angora Goat

Cashmere Goat

Cashmere Goat

Kebsch

Klipspringer

Kudu

Kudu

Kudu

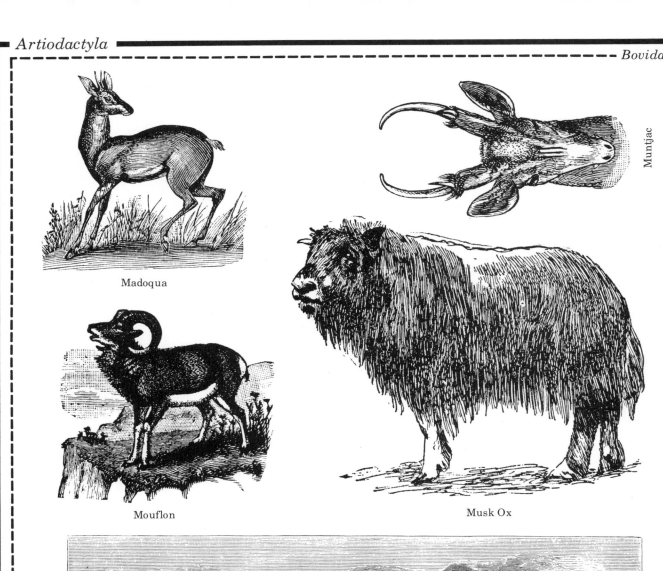

Madoqua

Muntjac

Mouflon

Musk Ox

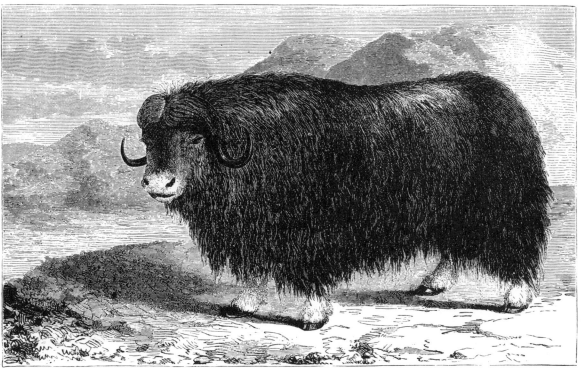

Musk Ox

Nilgai

Nilgai

Nilgai

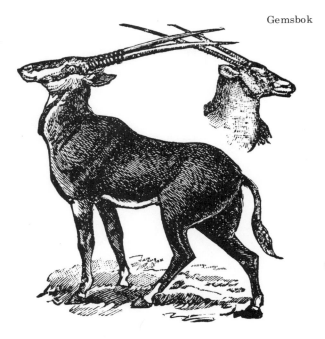

Gemsbok

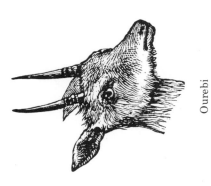

Ourebi

Oryx, Abyssinian

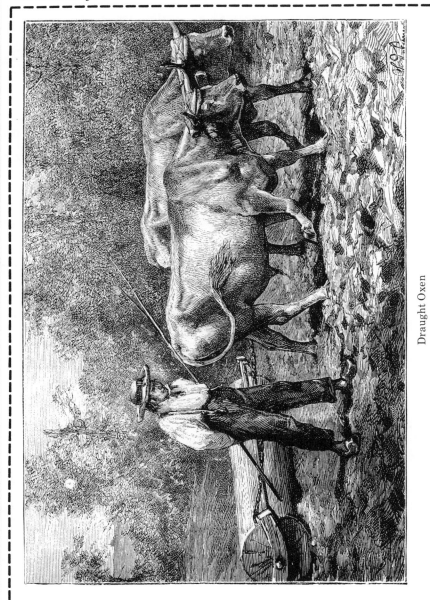

Draught Oxen

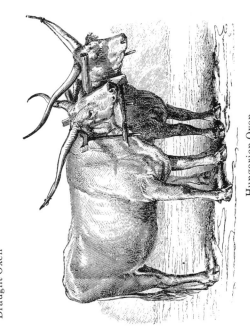

Hungarian Oxen

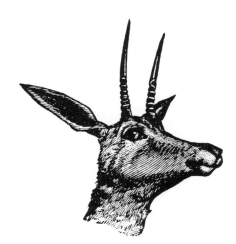

Reebok

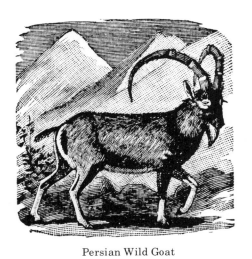

Persian Wild Goat

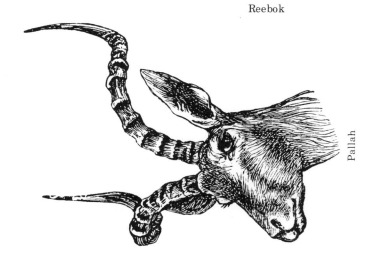

Pallah

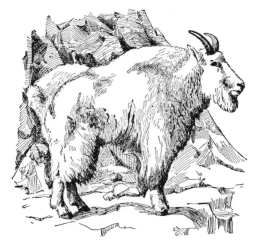

Rocky Mountain Goat

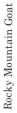
Rocky Mountain Goat

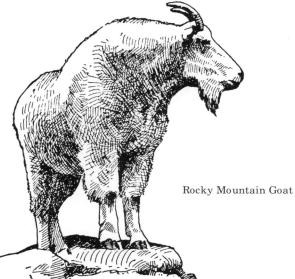

Rocky Mountain Goat

Rocky Mountain Goat

Sable Antelope

Sable Antelope

Sable Antelope

Saiga

Sakeen

Sassaby

Saiga

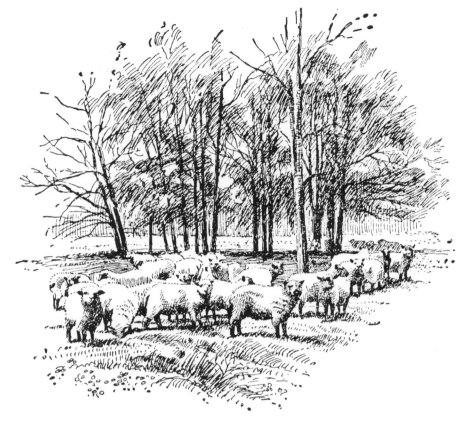

Sheep

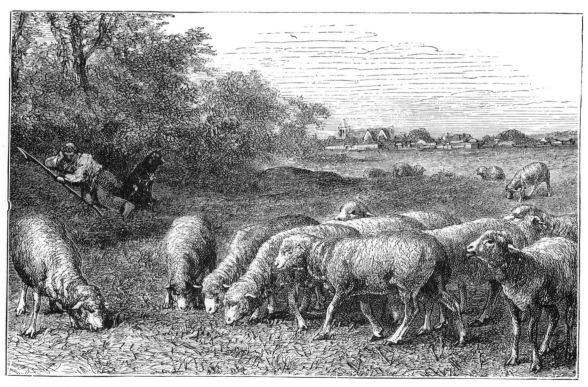

Sheep

Black Breed of the Landes (Ram)

Blackfaced Highland Ram

Cheviot Ewe

Cotswold Ewe

Cotswold Ram

Cotswold Ewe

Dorset Horn Ram

Fat-tailed

Hampshire Down Ram

Breed of Larzac

Leicester

Leicester Ewe

Lincoln Ram

Lincoln Ram

Delaine Merino Ram

American Merino Ram

Merino Ram

Mauchamp Merino Ram

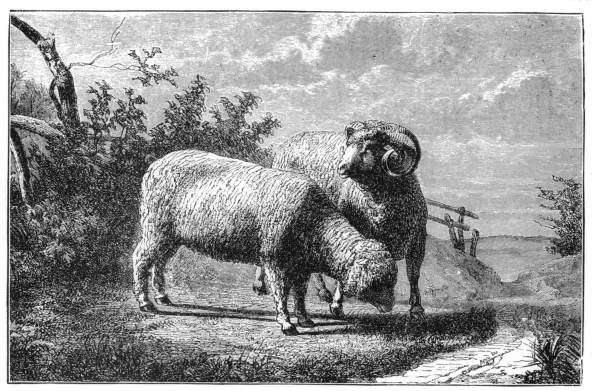

Rambouillet Merino Ram and Ewe

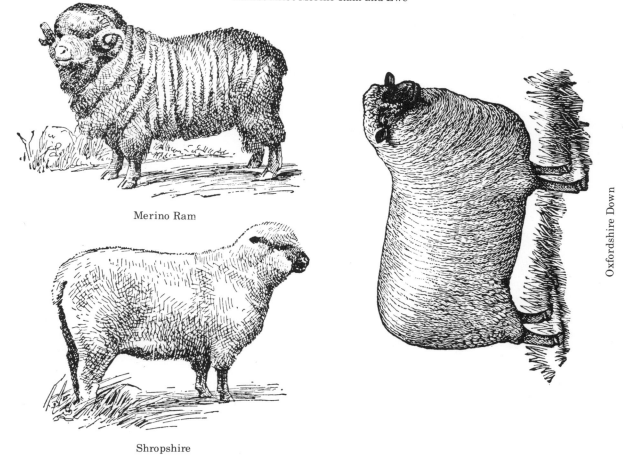

Merino Ram

Shropshire

Oxfordshire Down

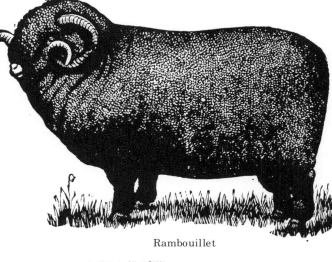

Rambouillet

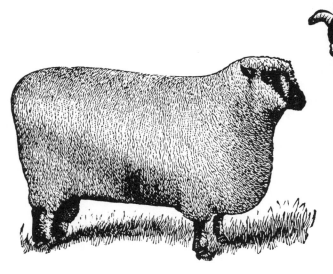

Shropshire

Southdown

Southdown

Touareg Ram

Welsh Ram

Singsing

Springbok

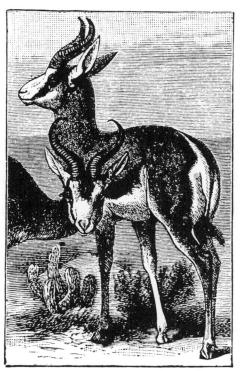

Springbok

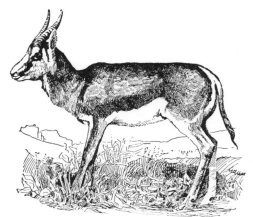

Springbok

Tora

Steenbok

Urial

Wariatu

Water-buck

Water Buffalo

Zebu

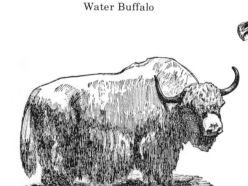

Water Buffalo

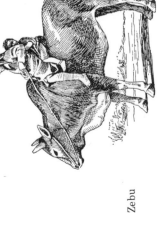

Zebu

Zebu

Yak

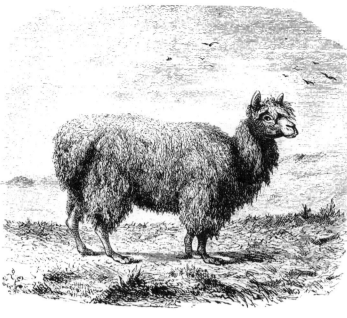

Alpaca

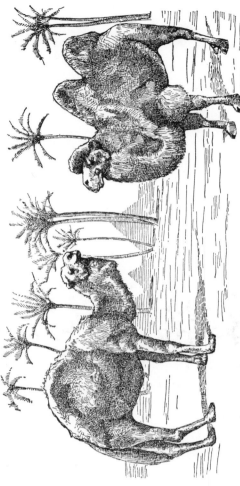

Bactrian Camel

Arabian Camel

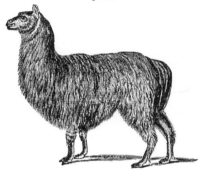

Alpaca

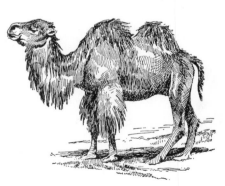

Bactrian Camel

Arabian Camel

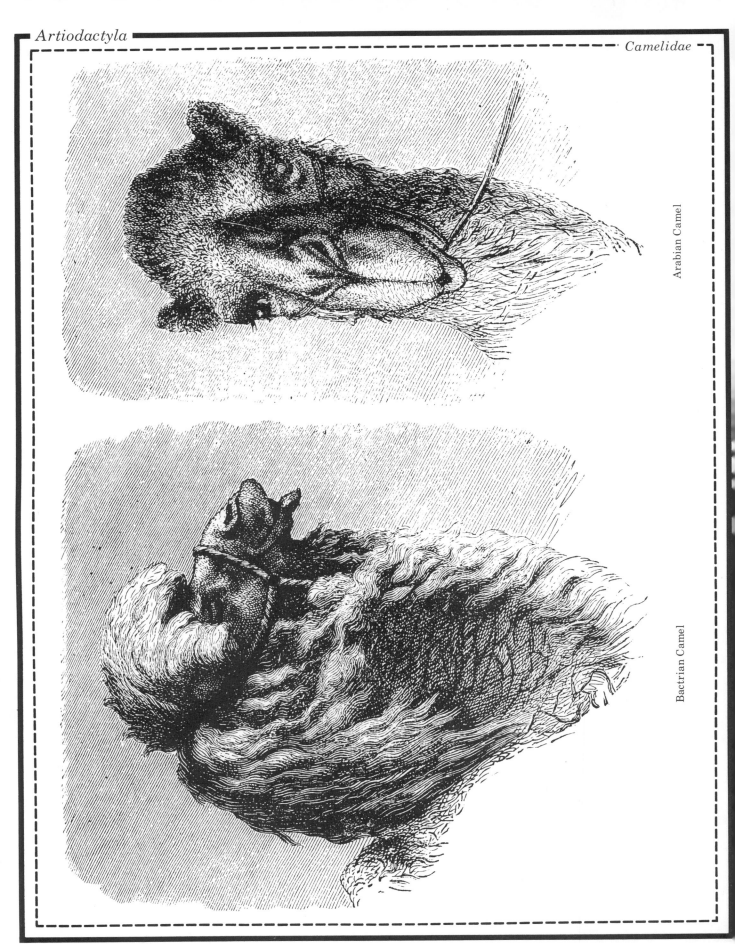

Arabian Camel

Bactrian Camel

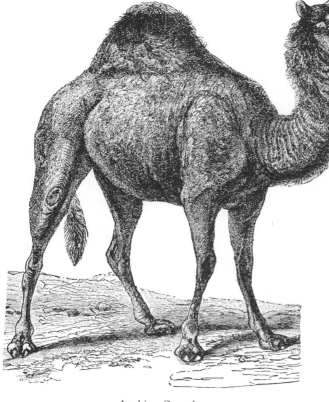

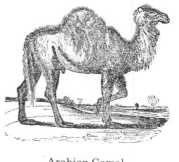

Arabian Camel

Arabian Camel

Guanaco

Llama

Llama

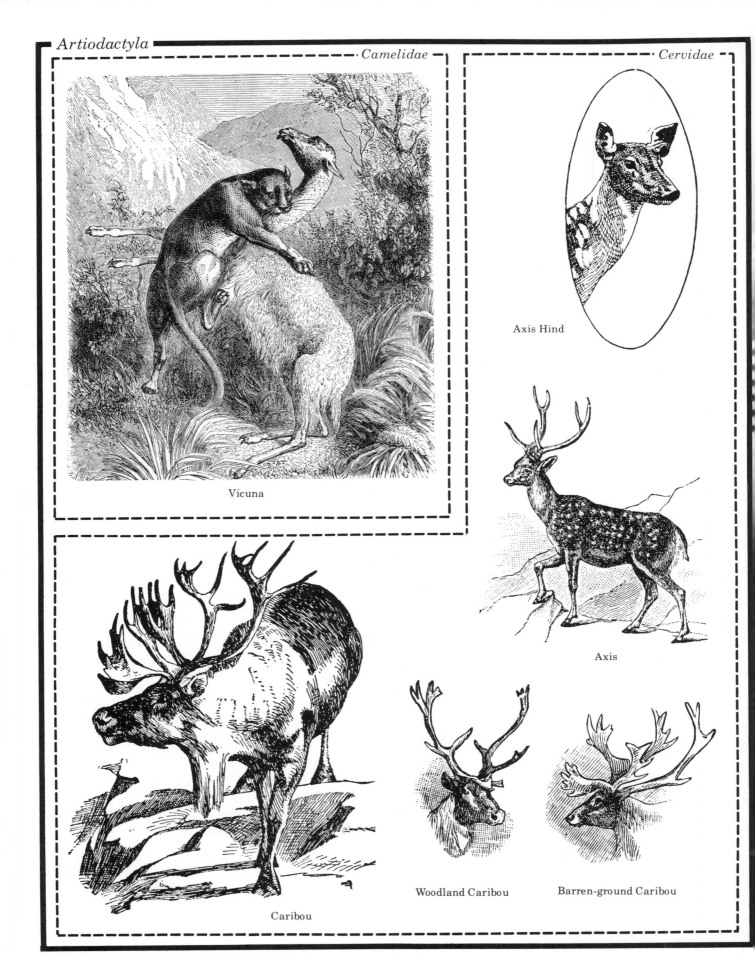

Camelidae

Cervidae

Axis Hind

Vicuna

Axis

Woodland Caribou

Barren-ground Caribou

Caribou

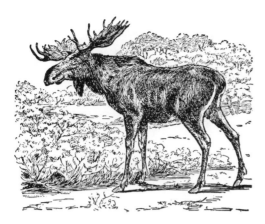

European Elk

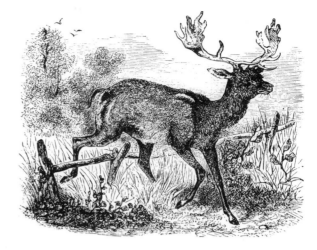

Fallow Deer

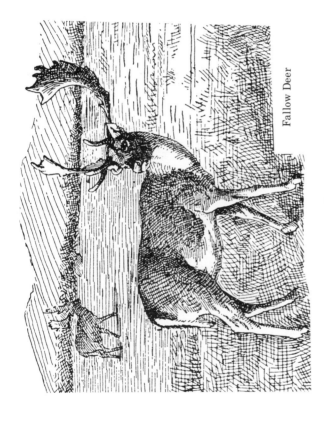

Fallow Deer

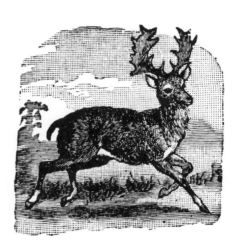

Fallow Deer

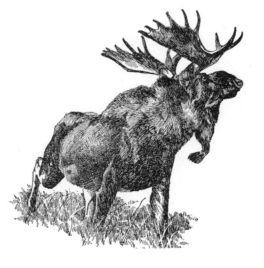

Moose

Moose

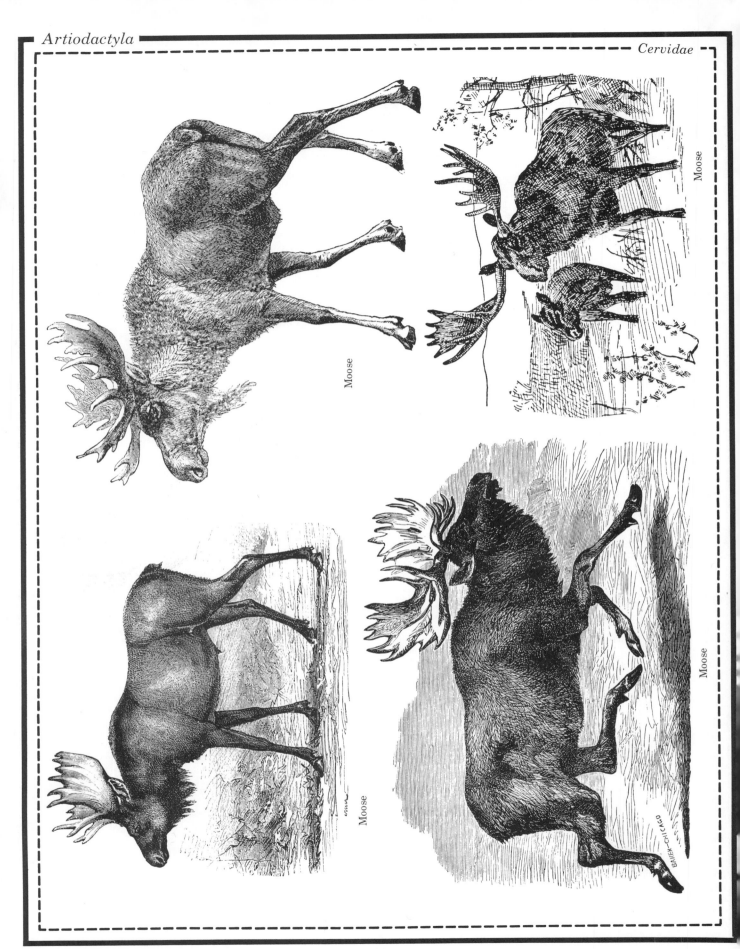

Moose

Moose

Moose

Moose

Moose

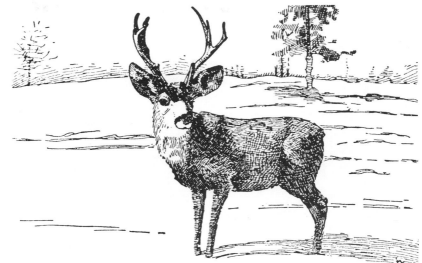

Mule Deer

Mule Deer

Musk Deer

Père David's Deer

Pigmy Musk Deer

Reindeer

Reindeer

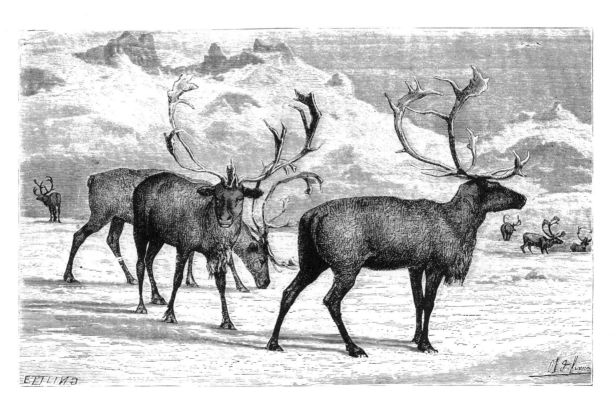

Reindeer

Reindeer

Reindeer

Reindeer

Reindeer

Reindeer

Roebuck

Sika

Roe Deer

Roebuck

Virginia Deer

Virginia Deer

Sambar

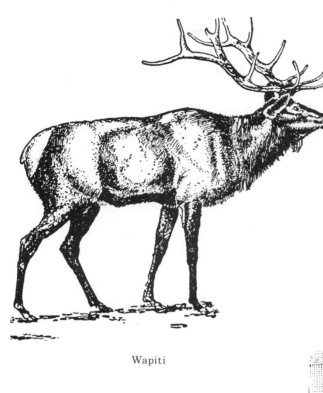

Wapiti

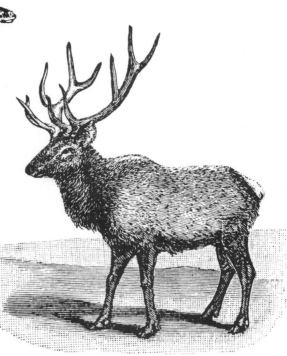

Wapiti

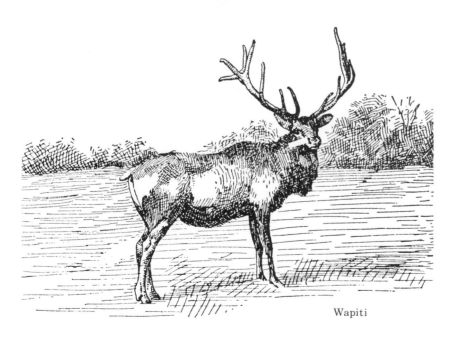

Wapiti

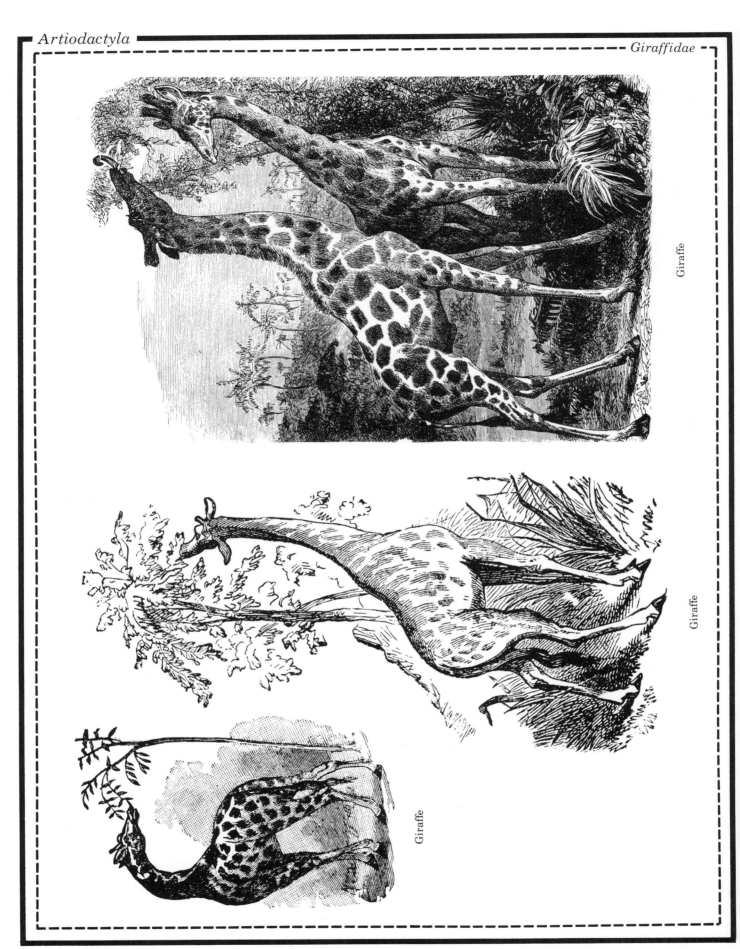

Giraffe

Giraffe

Giraffe

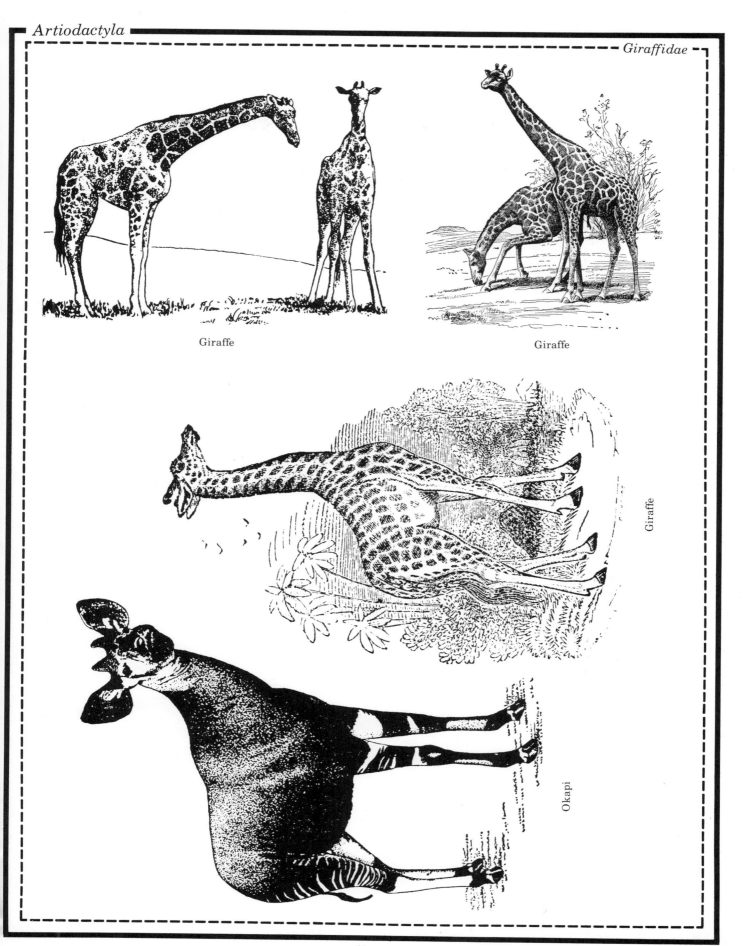

Giraffe

Giraffe

Giraffe

Okapi

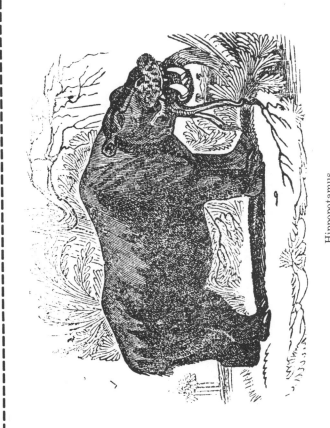

Hippopotamus

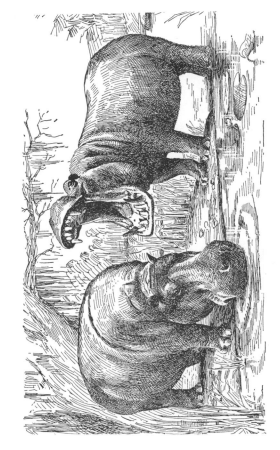

Hippopotamus

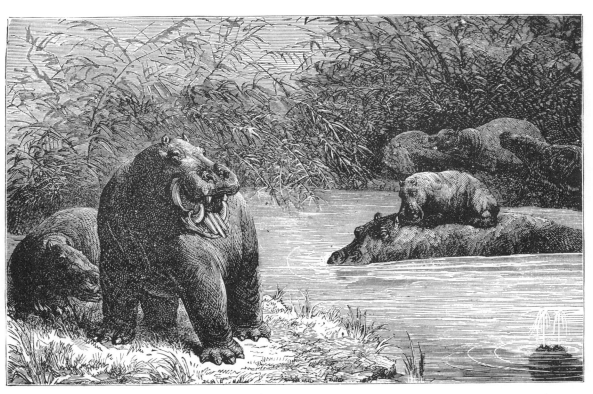

Hippopotamus

Babiroussa

Babiroussa

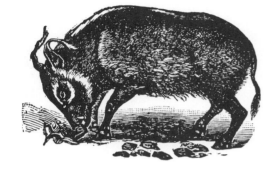

Boschvark

Wart Hog

Wart Hog

Wild Boar

Wild Boar

Berkshire Boar

Berkshire Boar

Bressane Sow

Chester White Boar

Duroc-Jersey Boar

Craonnese Boar

English White Boar

Wild Boar

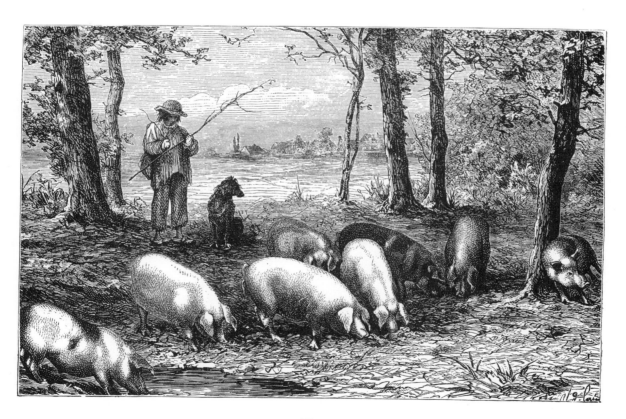

Pigs

Essex Sow

Perigord Boar

Poland-China Boar

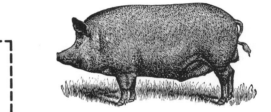

Tamworth Boar

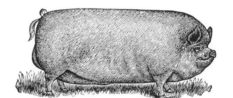

Yorkshire Boar

Tayassuidae

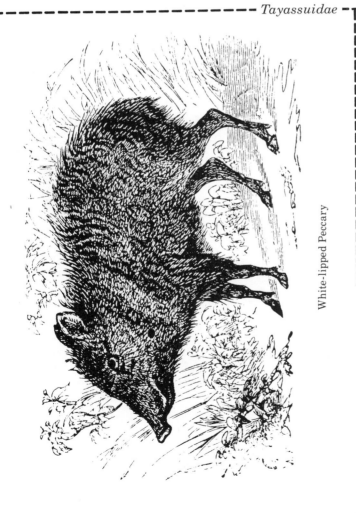

White-lipped Peccary

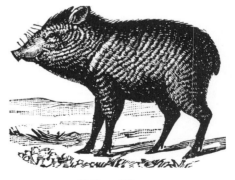

Collared Peccary

African Hunting Dog

Coyote

Coyote

Coyote

Dingo Dhole

Fennec

Fox

Silver Fox

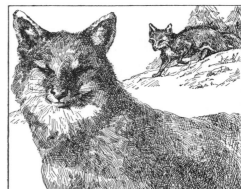

Silver Fox

Fox

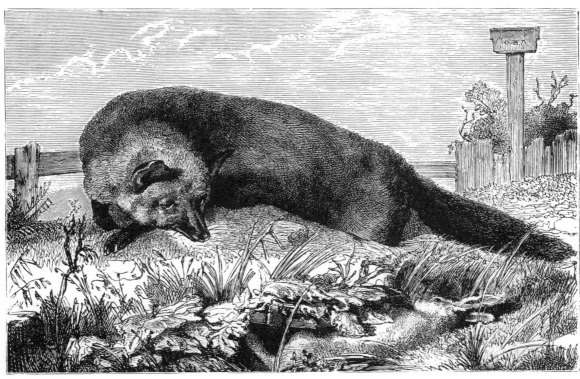

Fox

Fox

Jackal

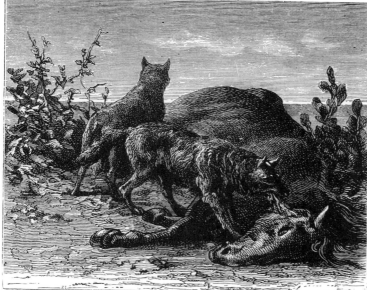

Jackal

Pied Thous

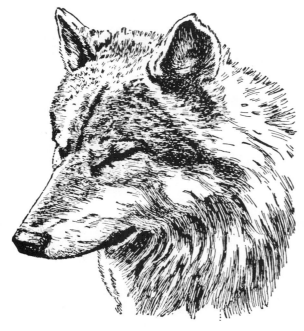

Wolf

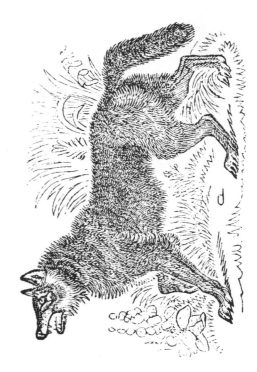

Wolf

Wolf

Wolf

African Bloodhound

Airedale

Basset

Beagle

Bloodhound

Bedlington Terrier

Boston Terrier

Bulldogs

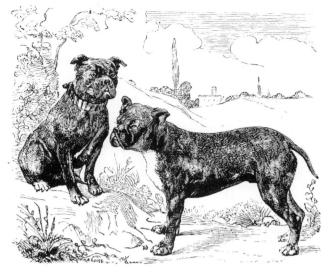

Bulldog

Bulldog

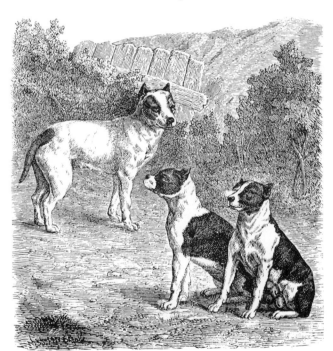

Bull Terrier

Bull Terrier

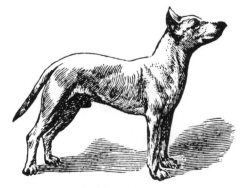

Bull Terrier

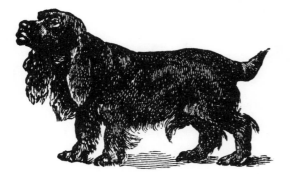

Cocker Spaniel

Collie

Collie

Dachshound

Collie

Dandie Dinmont

Dachshound

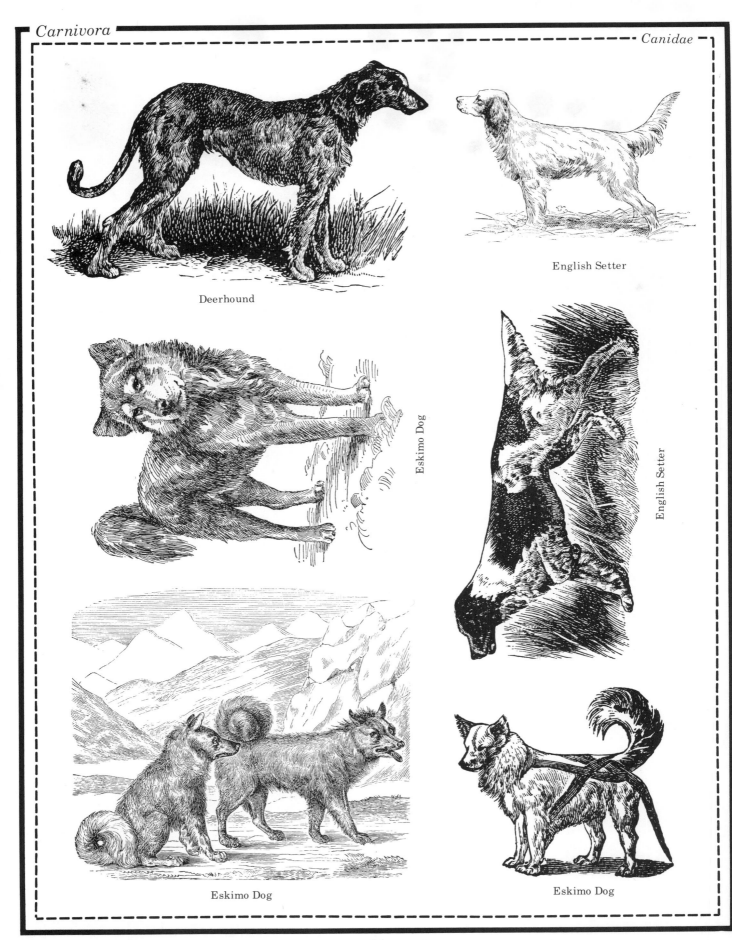

Deerhound

English Setter

Eskimo Dog

English Setter

Eskimo Dog

Eskimo Dog

Foxhound

Foxhound

Smooth Fox Terrier

Smooth Fox Terrier

Wire-haired Fox Terrier

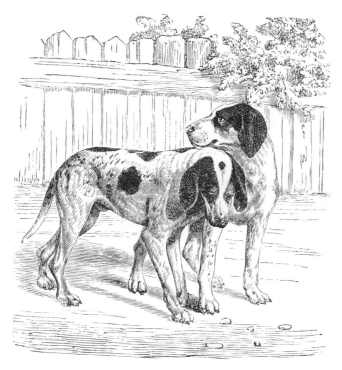

Gascony Hound

French Black Poodle

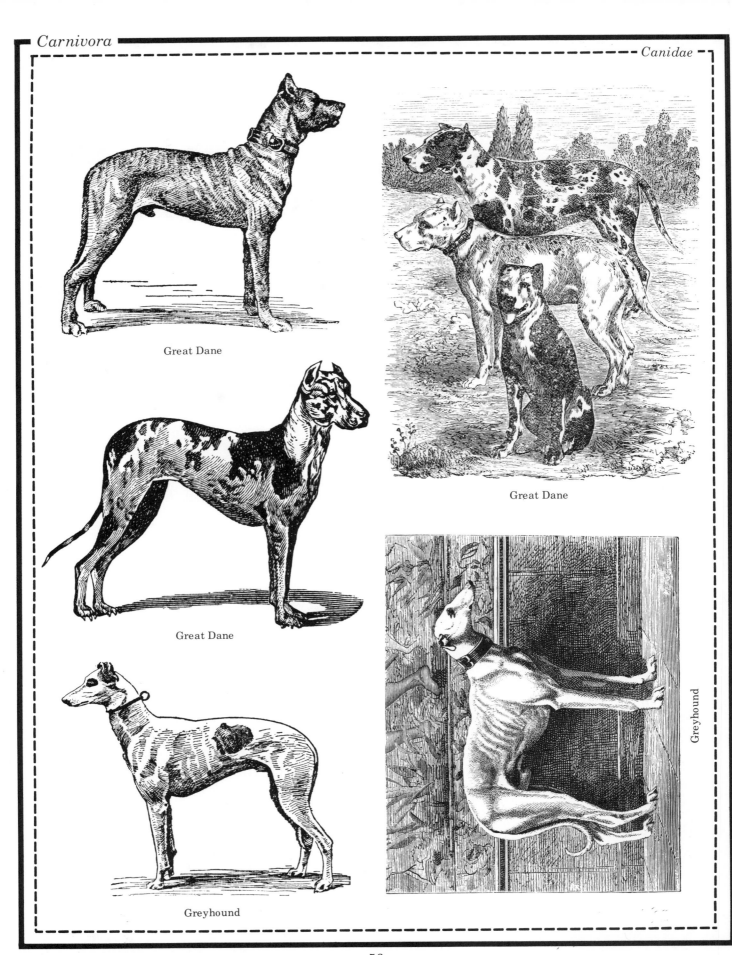

Great Dane

Great Dane

Great Dane

Greyhound

Greyhound

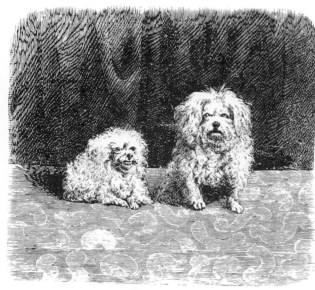

Havanese

Highland Hound

Japanese Spaniel

Irish Water Spaniel

Land Spaniel

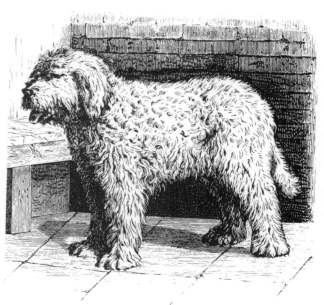

Large French Water Spaniel

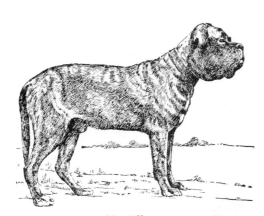

Mastiff

Mastiff

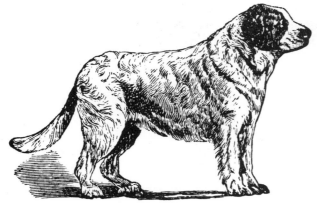

Newfoundland

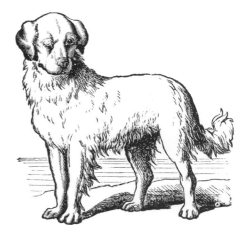

Newfoundland

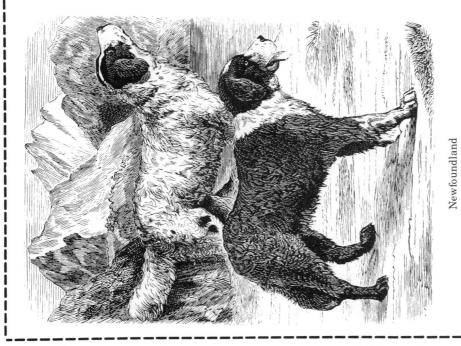

Newfoundland

Newfoundland

Pointer

Pointer

Pointer

Pointer

Poodle

Pug

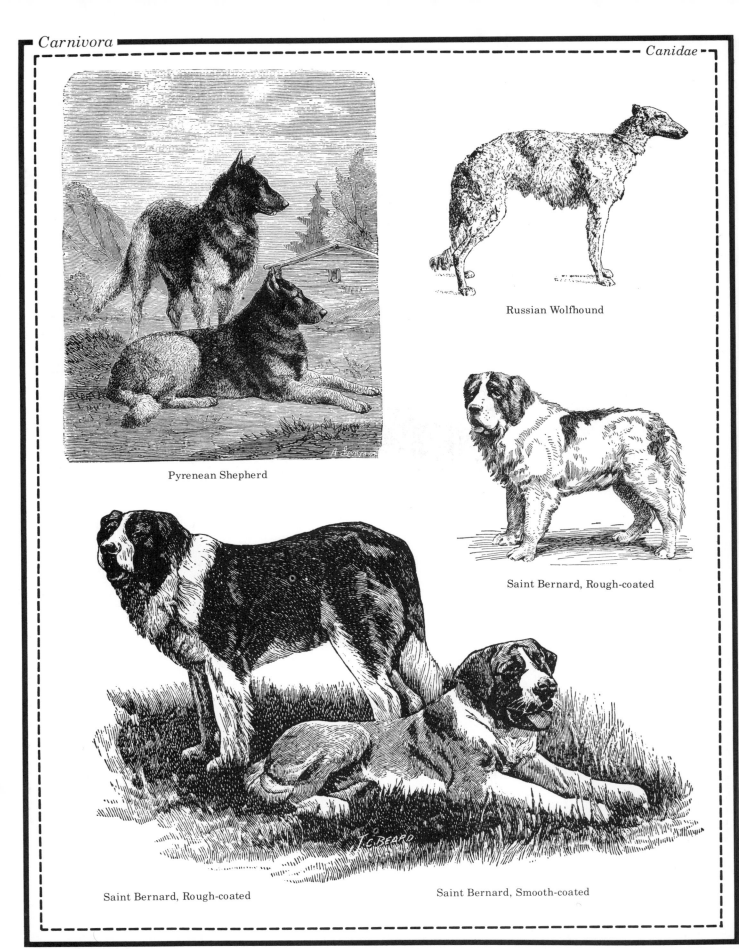

Pyrenean Shepherd

Russian Wolfhound

Saint Bernard, Rough-coated

Saint Bernard, Rough-coated

Saint Bernard, Smooth-coated

Scotch Terrier

Scotch Terrier

Scotch Terrier

Schipperke

Setter

Skye Terrier

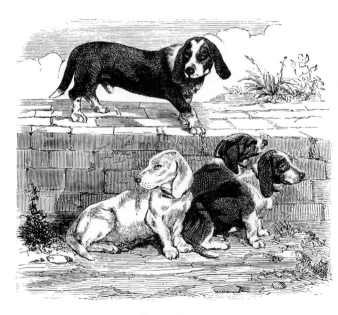

Turnspit

Warwickshire Foxhound

Yorkshire Terrier

Angora

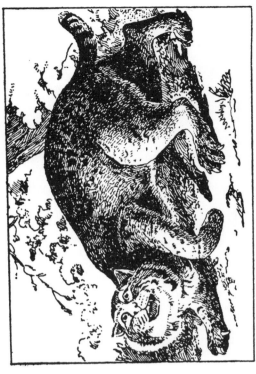

Bobcat

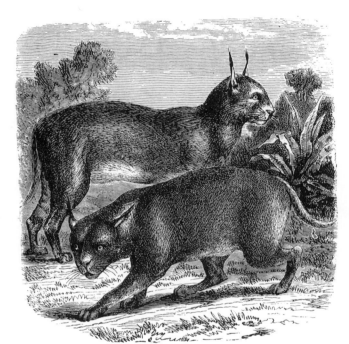

Caracal

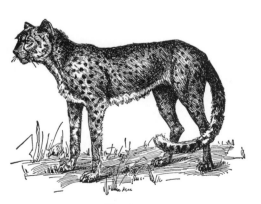

Cheeta

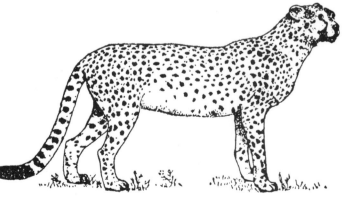

Chaus

Cheeta

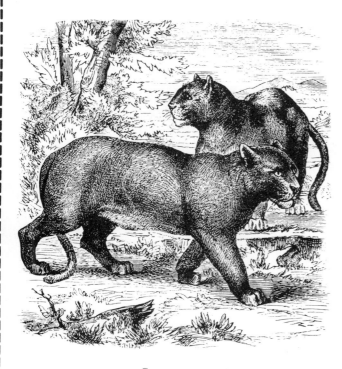

Cougar

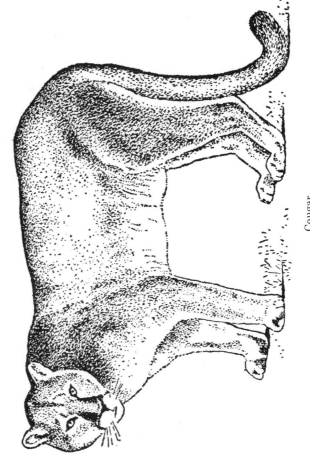

Cougar

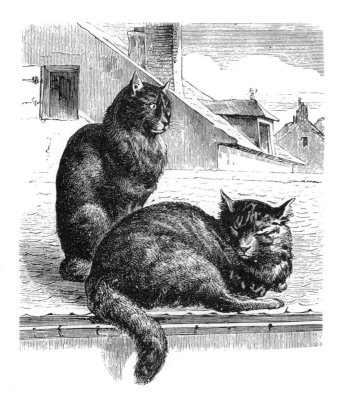

Domestic Cat

Domestic Cat

Eyra

Jaguar

Jaguar

Jaguar

Jaguarundi

Leopard

Leopard

Leopard

Leopard

Leopard

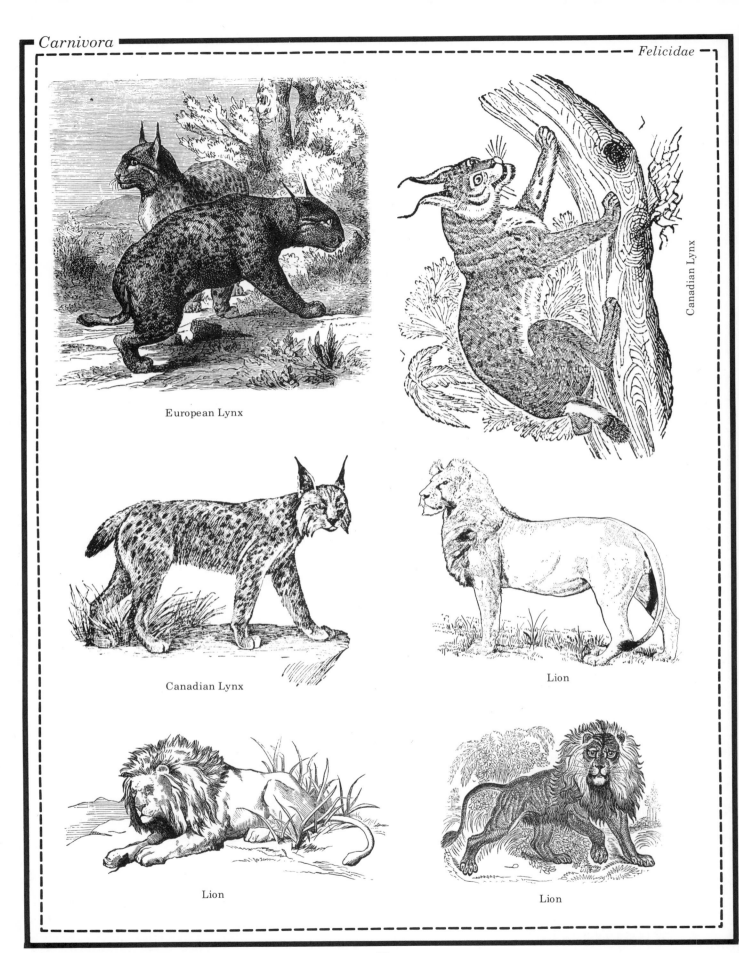

European Lynx

Canadian Lynx

Canadian Lynx

Lion

Lion

Lion

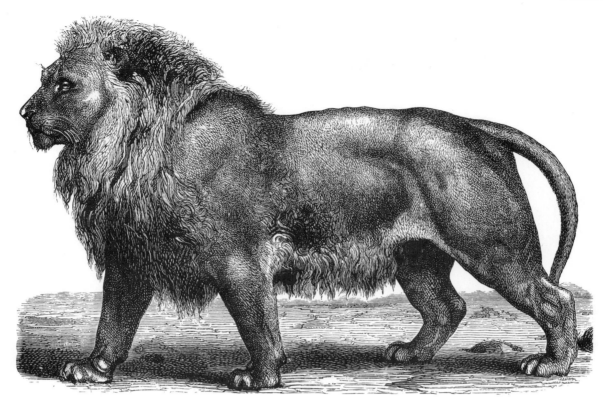

Lion

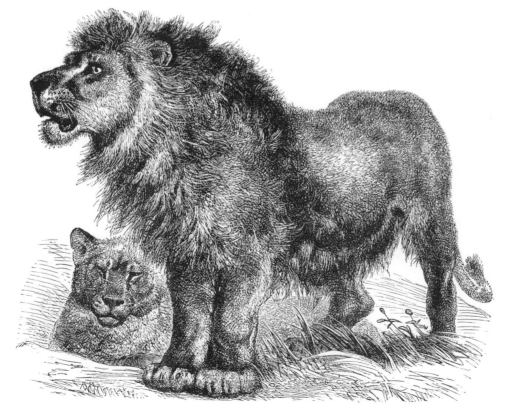

Persian Lion

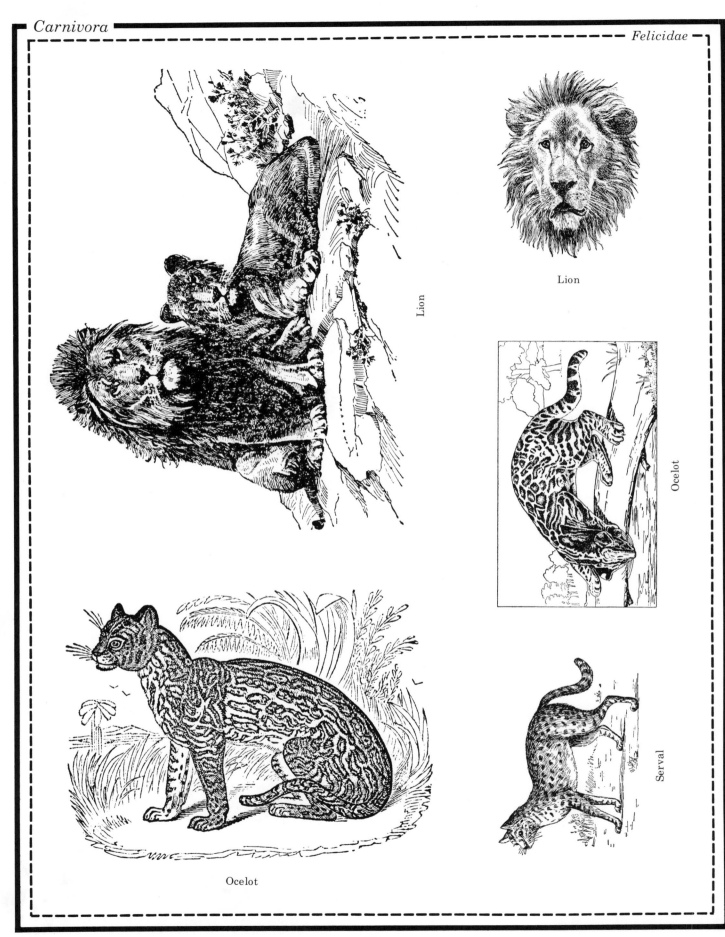

Lion

Lion

Ocelot

Serval

Ocelot

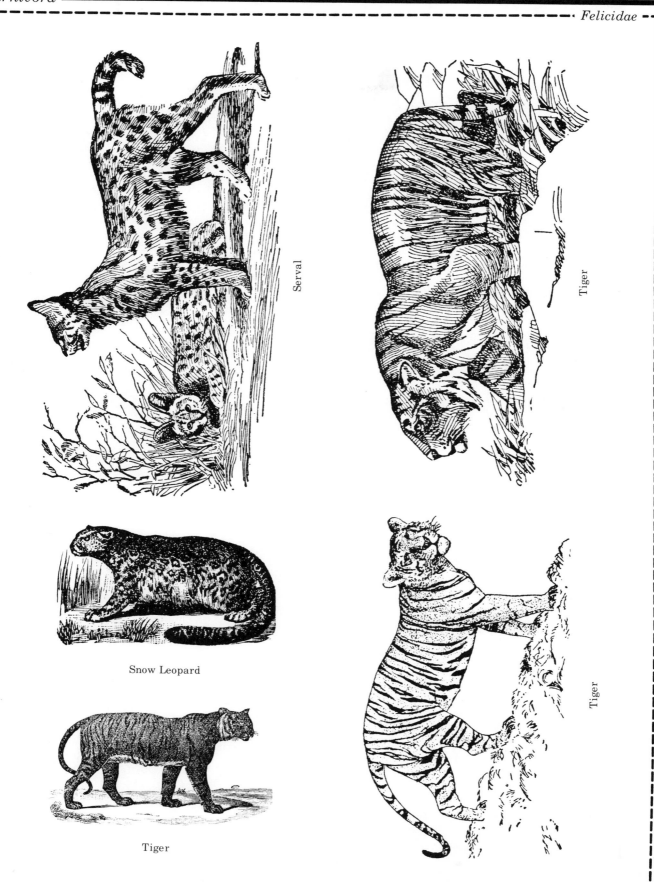

Serval

Tiger

Snow Leopard

Tiger

Tiger

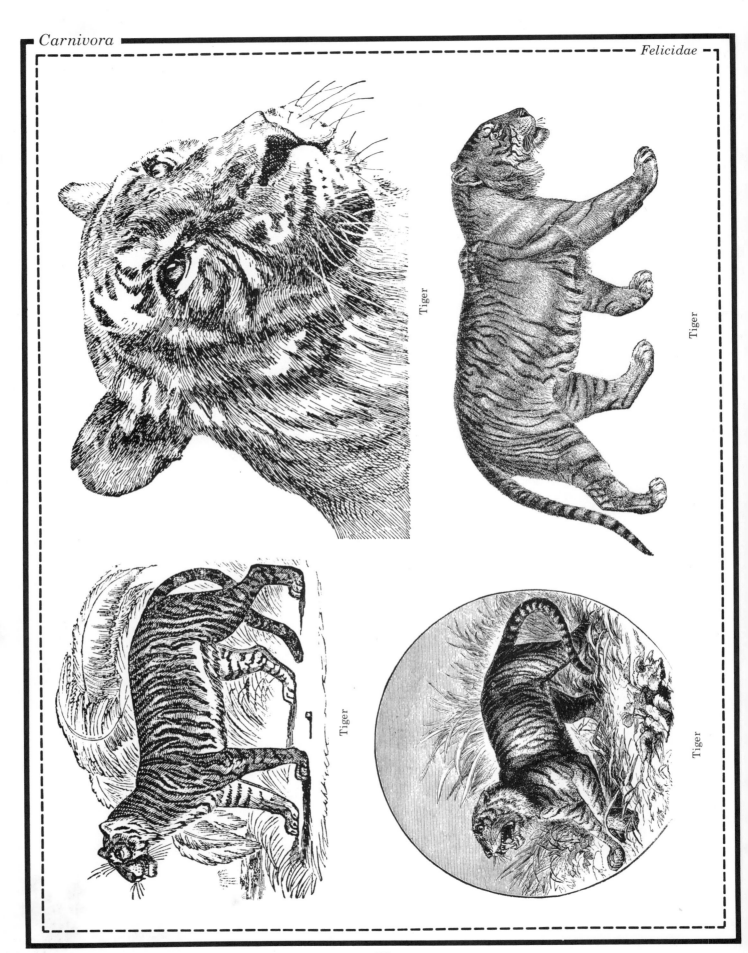

Tiger

Tiger

Tiger

Tiger

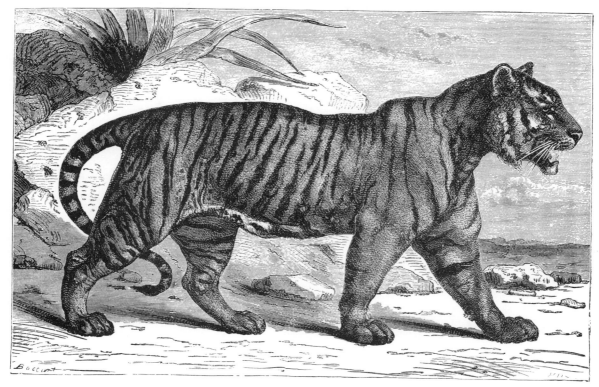

Tiger

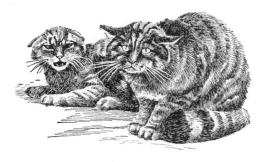

European Wild Cat

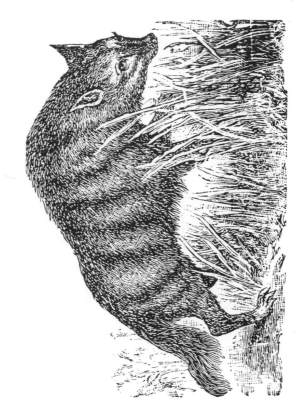

Aardwolf

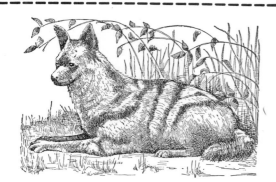

Aardwolf

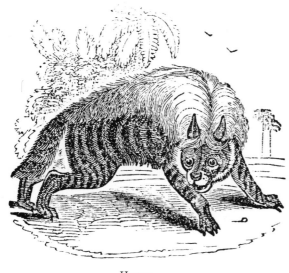

Hyena

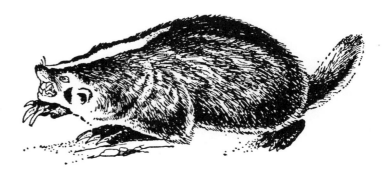

Spotted Hyena

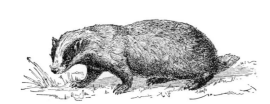

Badger

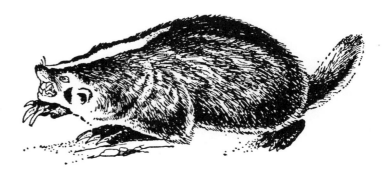

Common Badger

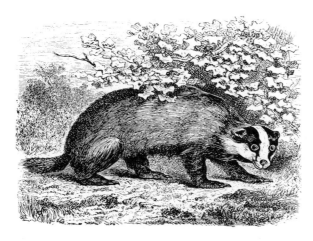

American Badger

Balisaur

Ferret

Ferret

Beech Marten

Fisher

Otter

Pine Marten

Polecat

European Otter

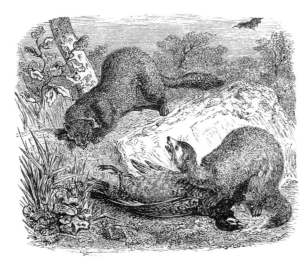

Polecat

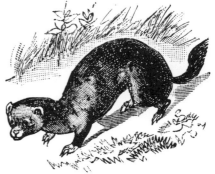

European Polecat

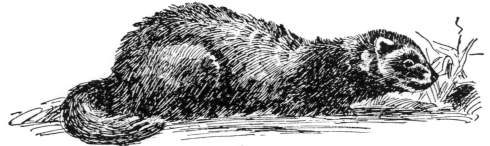

Otter

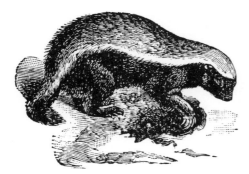

Ratel

Ratel

Sea Otter

Skunk

Skunk

Skunk

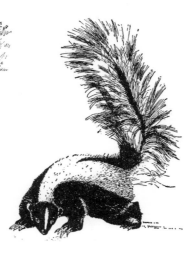

Skunk

Winter Coat

Summer Coat

Least Weasel

Summer Coat

Winter Coat

Shorttail Weasel

Longtail Weasel

Shorttail Weasel

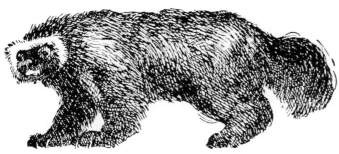

Wolverine

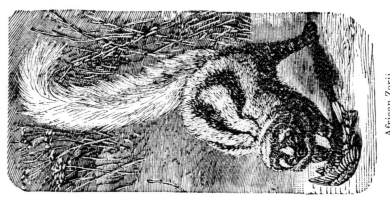

Wolverine

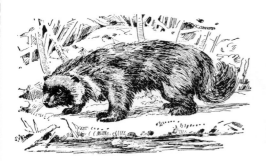

Wolverine

African Zorii

Procyonidae

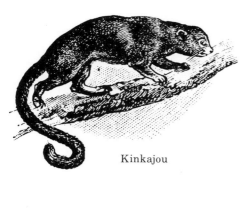

Kinkajou

Coati-mondi

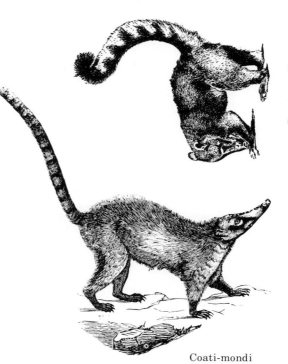

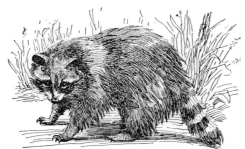

Raccoon

Coati-mondi

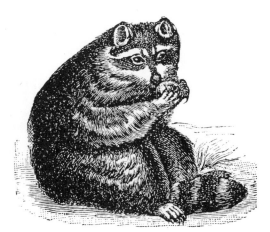

Raccoon

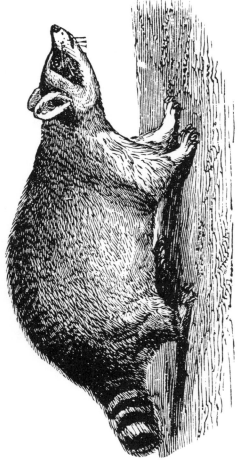

Raccoon

Raccoon

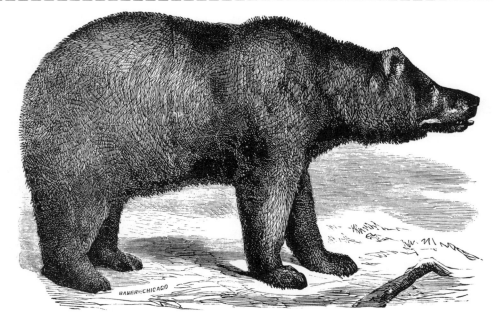

Black Bear

Black Bear

Brown Bear

Black Bear

Brown Bear

Grizzly Bear

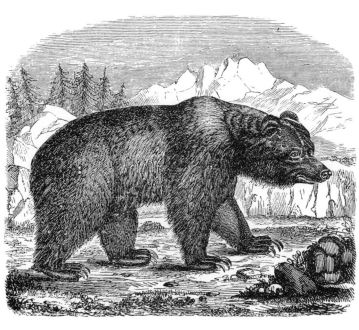

Brown Bear

Grizzly Bear

Grizzly Bear

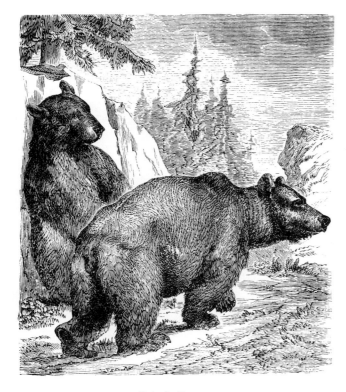

Grizzly Bear

Kodiak Bear

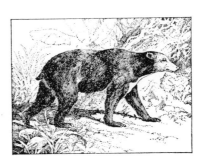

Malay Bear

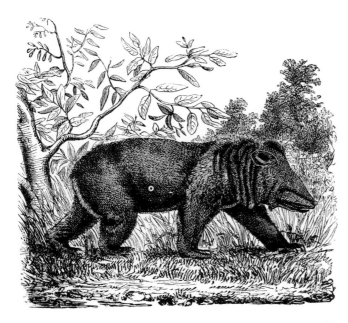

Malay Bear

Sloth Bear

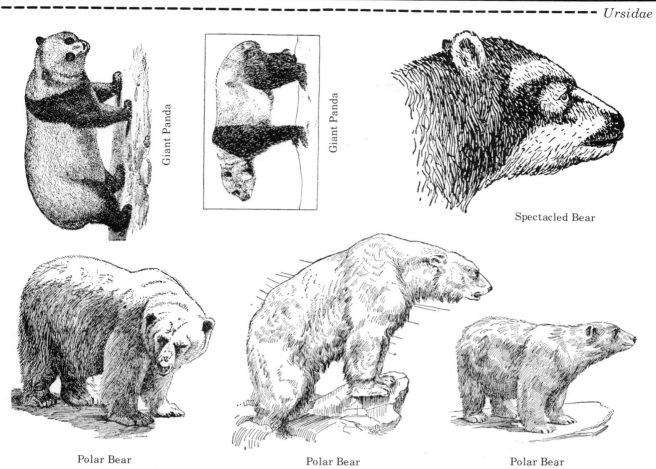

Giant Panda

Giant Panda

Spectacled Bear

Polar Bear

Polar Bear

Polar Bear

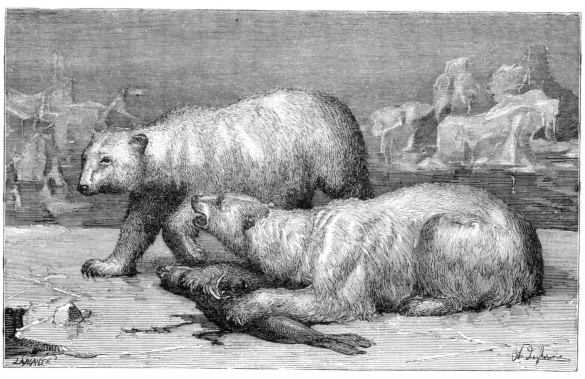

Polar Bear

Cacomistle

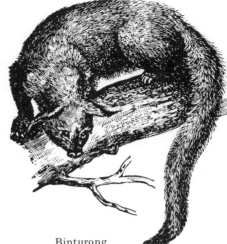

Binturong

Civet

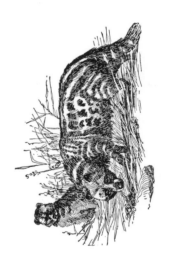

Civet

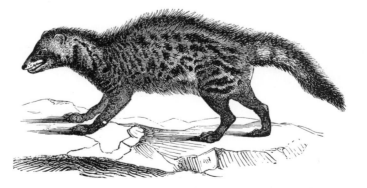

Civet

Genet

Palm Civit

Mongoose

Suricate

Urva

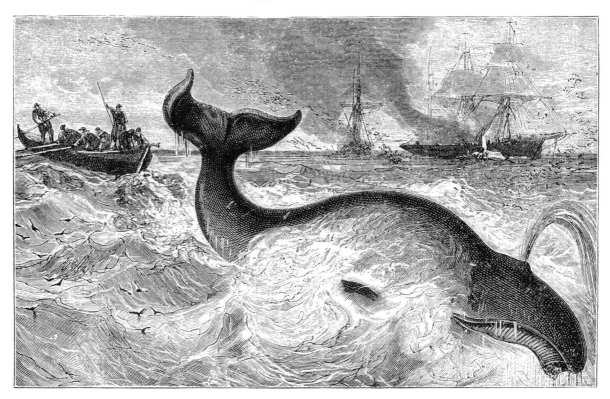

Right Whale

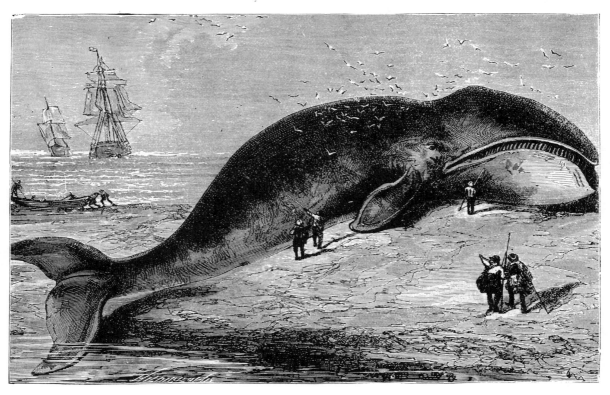

Right Whale

Cetacea (Sub-order *Mystacoceti*)

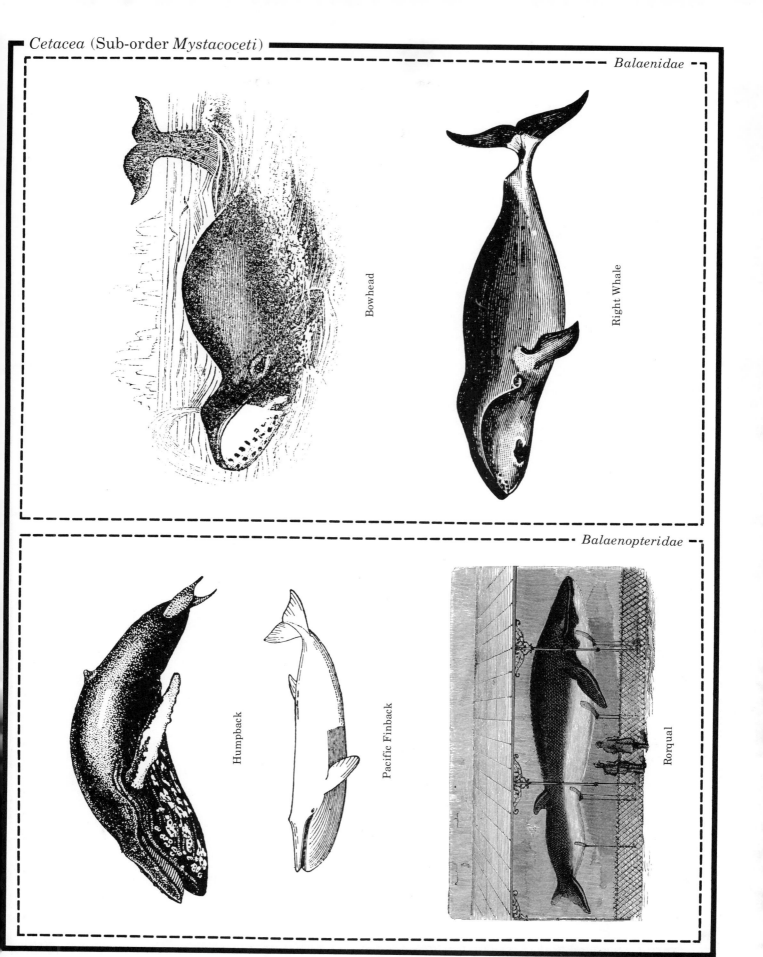

Balaenidae

Bowhead

Right Whale

Balaenopteridae

Humpback

Pacific Finback

Rorqual

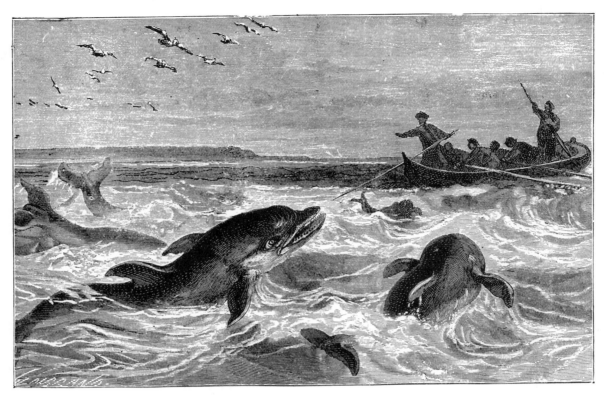

Dolphin

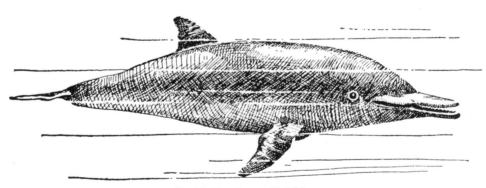

Pacific Bottlenose Dolphin

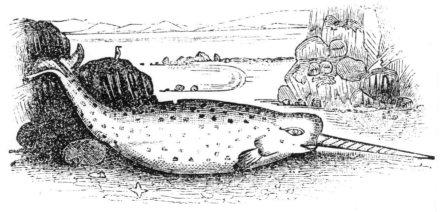

Narwhale

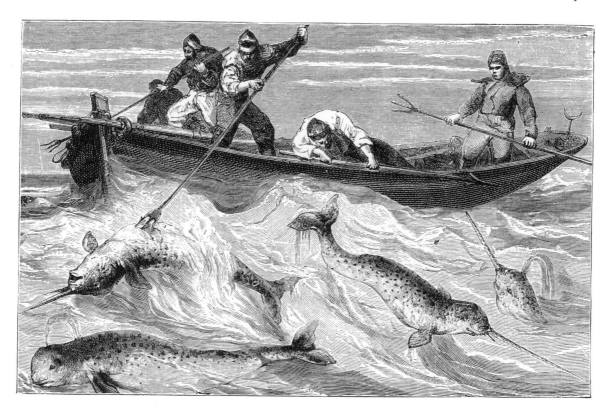

Narwhale

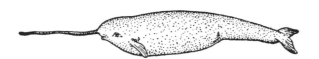

Narwhale

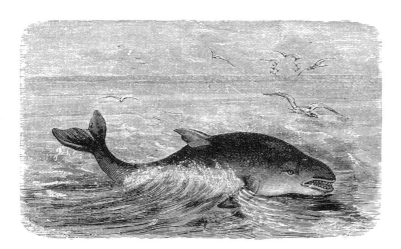

Atlantic Harbor Porpoise

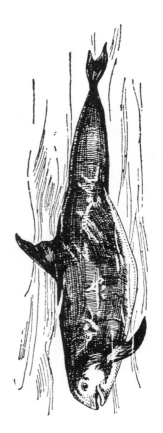

Porpoise

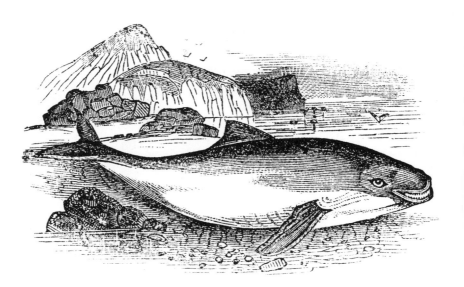

Dall Porpoise

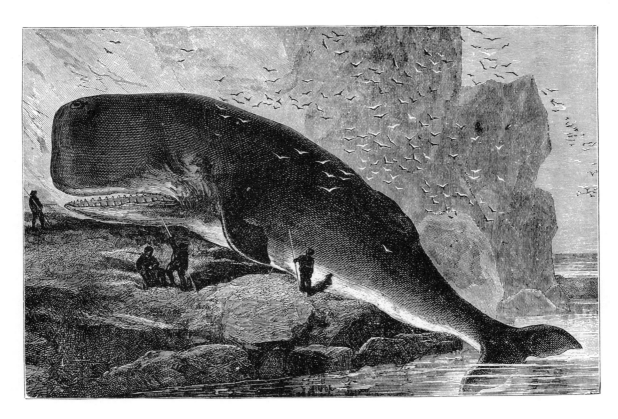

Sperm Whale

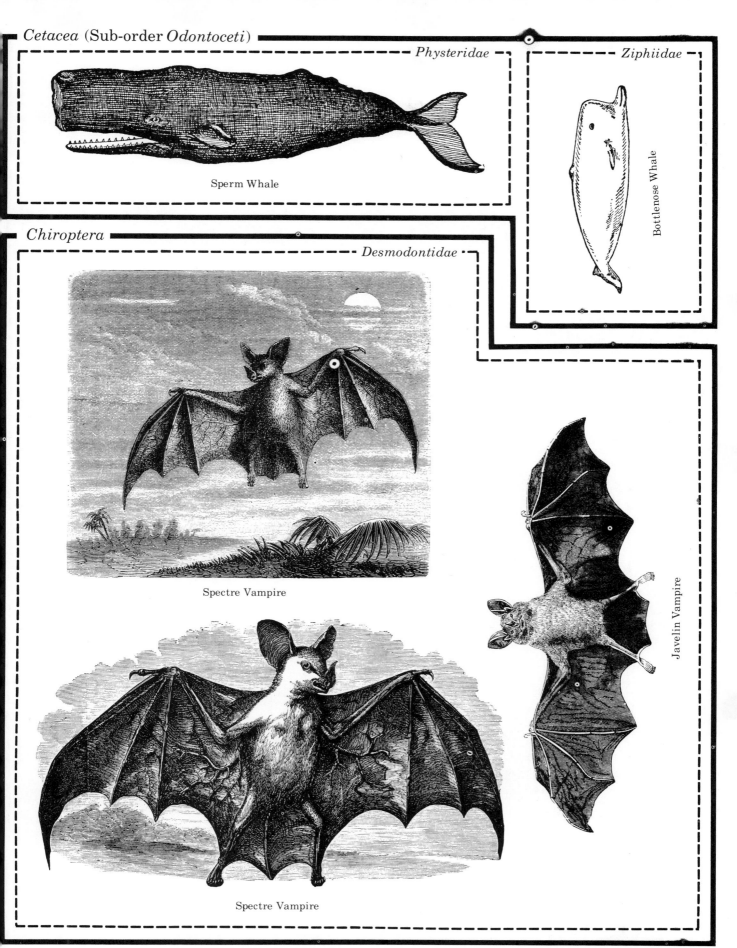

Cetacea (Sub-order *Odontoceti*)

Physeridae

Sperm Whale

Ziphiidae

Bottlenose Whale

Chiroptera

Desmodontidae

Spectre Vampire

Javelin Vampire

Spectre Vampire

Megadermatidae

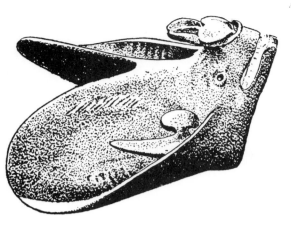

Big-eared Bat

Phyllostomatidae

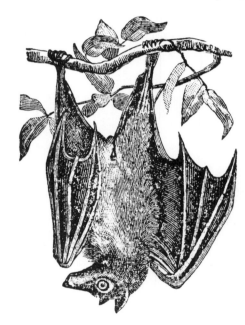

Leaf-nosed Bat

Pteropidae

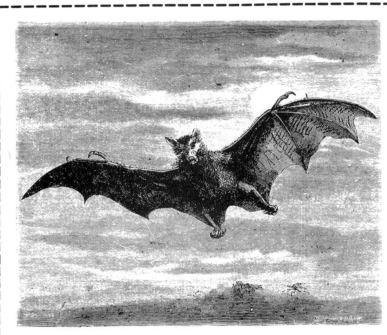

Flying Fox

Flying Fox

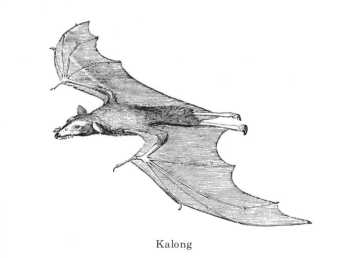

Kalong

Vespertilionidae

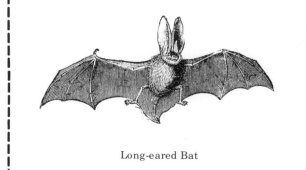

Long-eared Bat

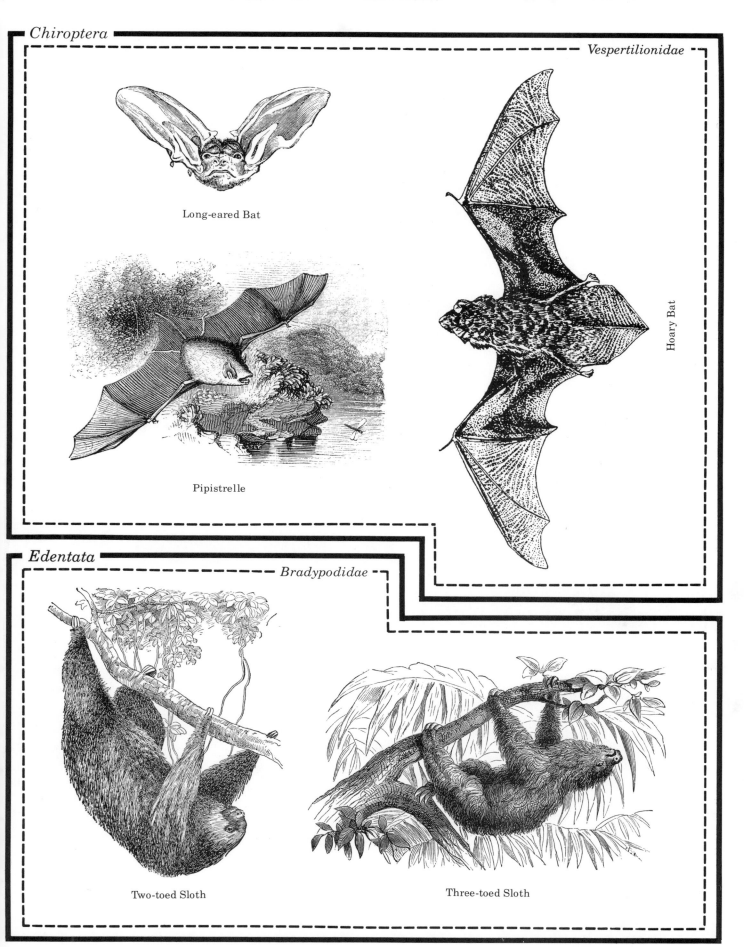

Vespertilionidae

Long-eared Bat

Hoary Bat

Pipistrelle

Edentata

Bradypodidae

Two-toed Sloth

Three-toed Sloth

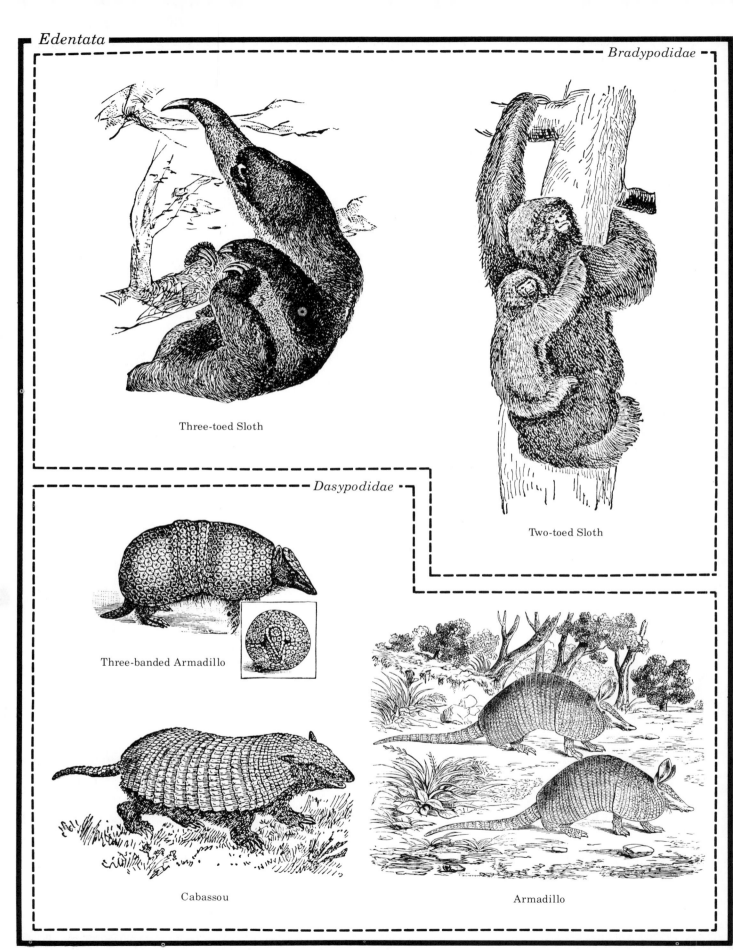

Bradypodidae

Dasypodidae

Three-toed Sloth

Two-toed Sloth

Three-banded Armadillo

Cabassou

Armadillo

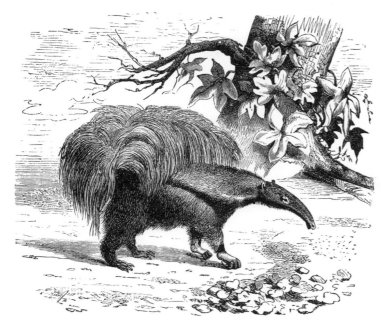

Giant Anteater

Giant Anteater

Giant Anteater

Giant Anteater

Australian Anteater

Tamandua

Procaviidae

Erinacidae

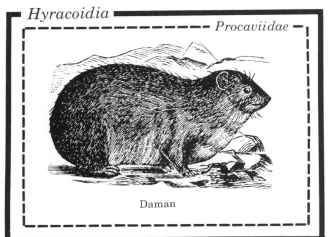

Daman

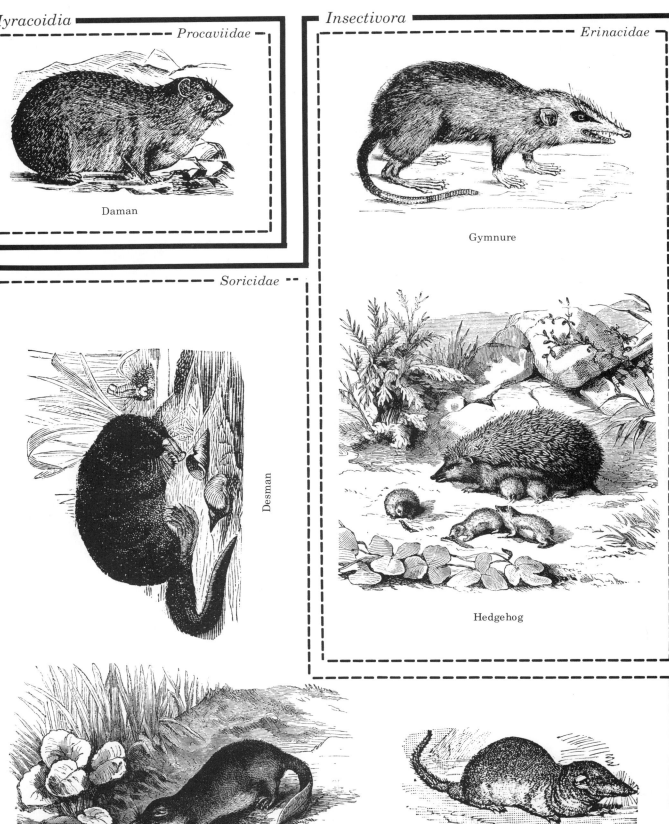

Gymnure

Soricidae

Desman

Hedgehog

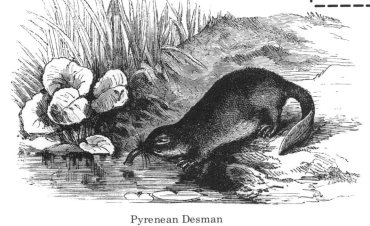

Pyrenean Desman

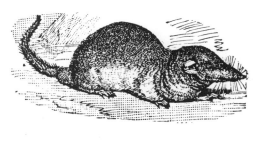

Common Shrew

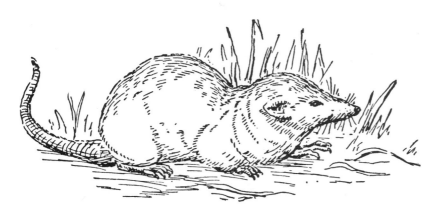

Common Shrew

Common Shrew

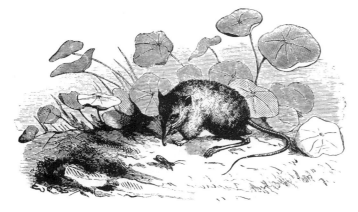

Elephant Shrew

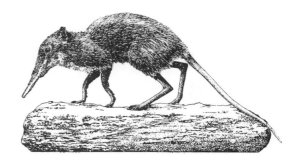

Elephant Shrew

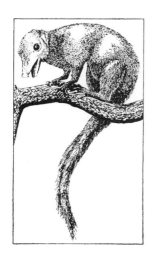

Tree Shrew

Water Shrew

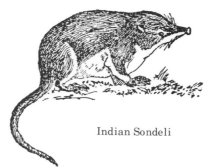

Indian Sondeli

Rat-tailed Sondeli

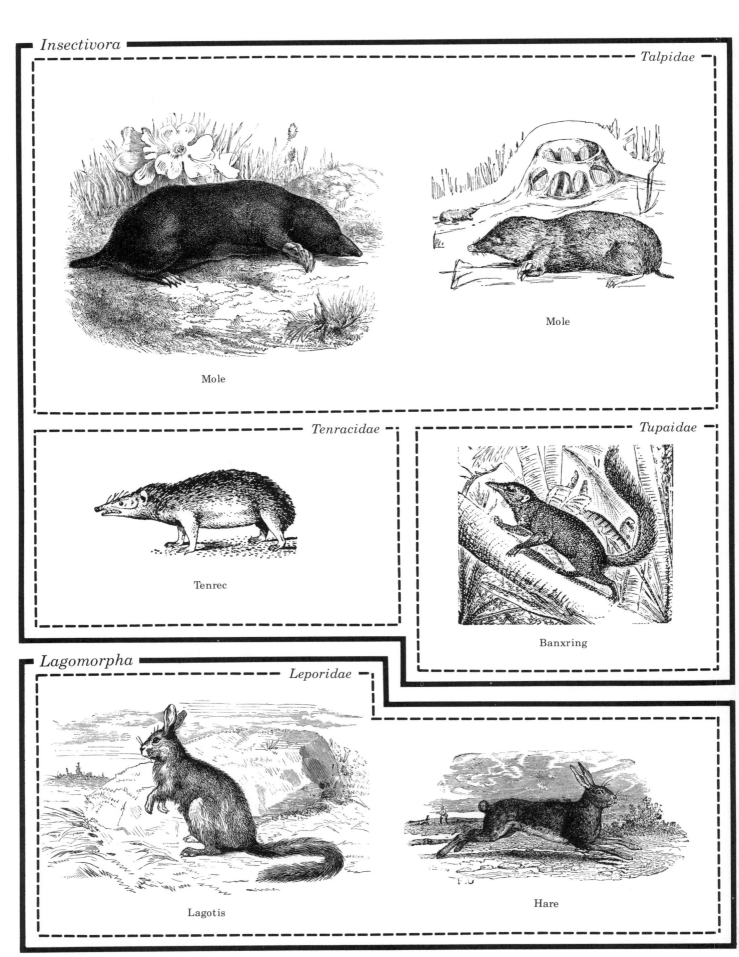

Insectivora

Talpidae

Mole

Mole

Tenracidae

Tenrec

Tupaidae

Banxring

Lagomorpha

Leporidae

Lagotis

Hare

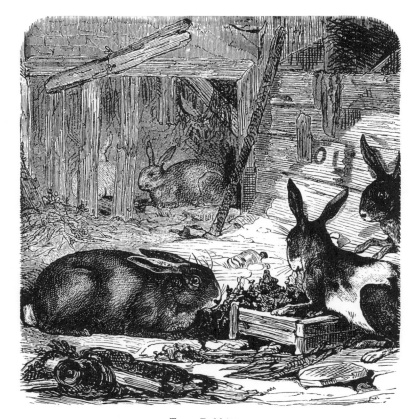

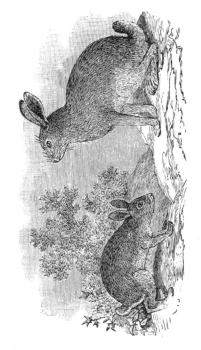

Tame Rabbit

Wild Rabbit

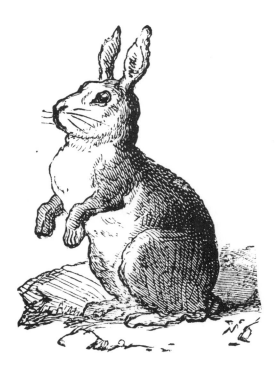

Rabbit

Wild Rabbit

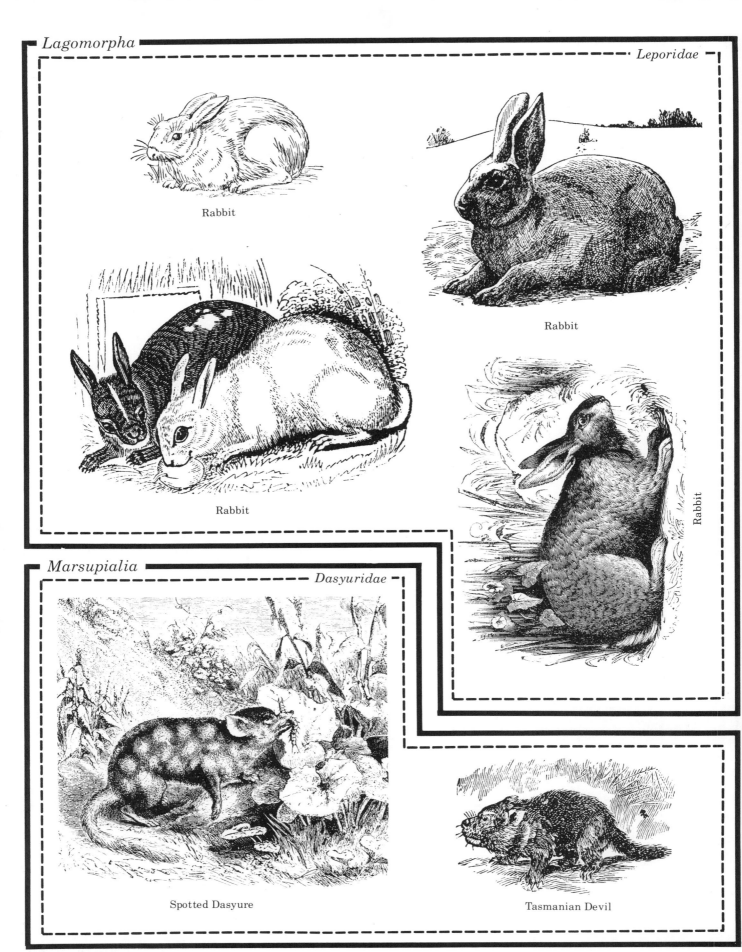

Leporidae

Rabbit

Rabbit

Rabbit

Rabbit

Marsupialia

Dasyuridae

Spotted Dasyure

Tasmanian Devil

Tasmanian Wolf

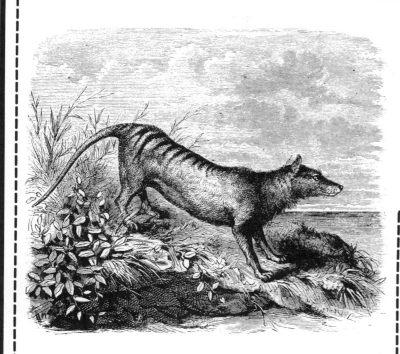

Tasmanian Wolf

Australian Opossum

Opossum

Murine Opossum

Didelphidae

Macropodidae

Filander

Virginia Opossum

Tufted-tailed Rat-kangaroo

Giant Kangaroo

Giant Kangaroo

Macropodidae

Phalangeridae

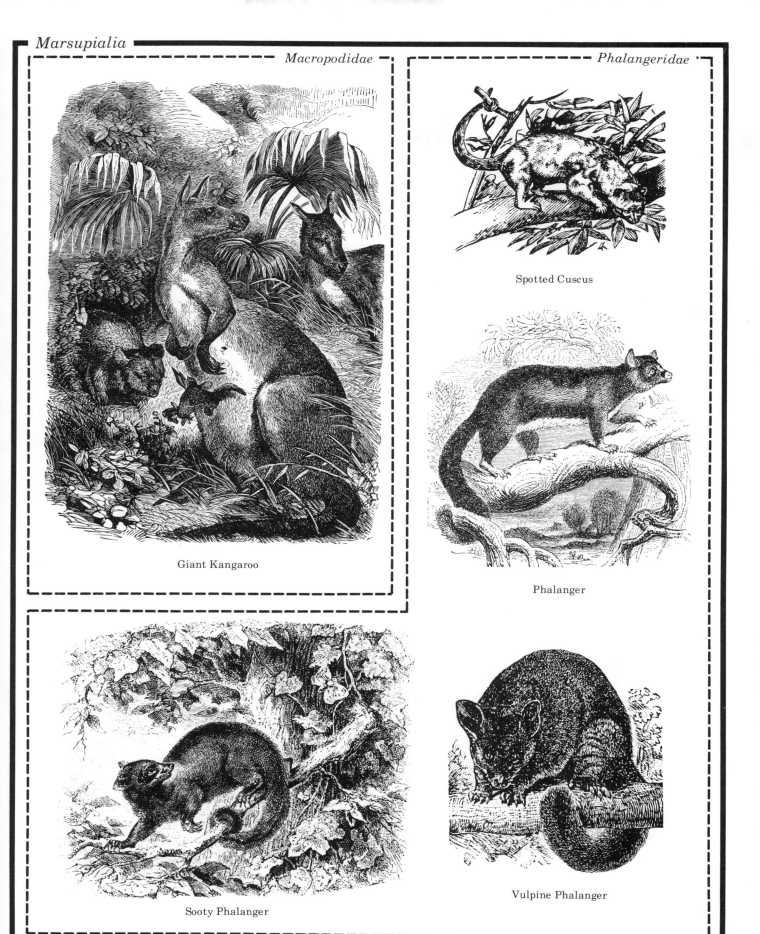

Spotted Cuscus

Giant Kangaroo

Phalanger

Sooty Phalanger

Vulpine Phalanger

Phascolomidae

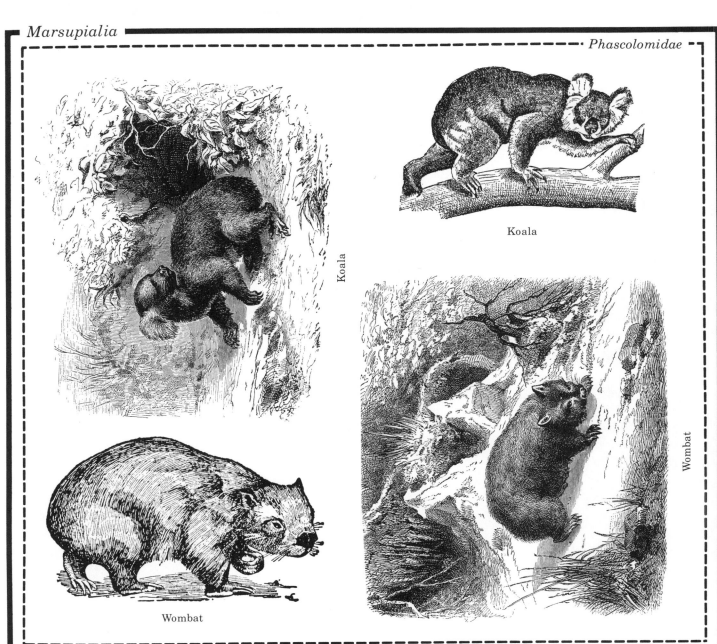

Koala

Koala

Wombat

Wombat

Monotremata

Orithorhynchidae

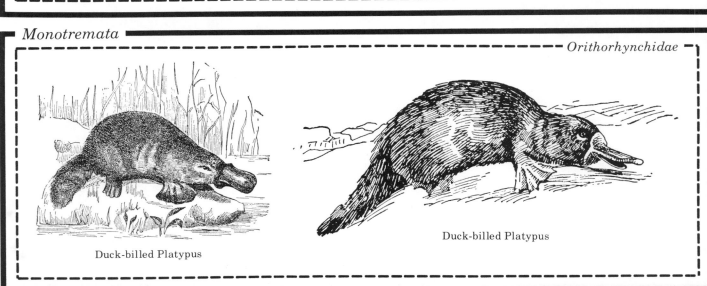

Duck-billed Platypus

Duck-billed Platypus

Monotremata

Orithorhynchidae

Tachyglossidae

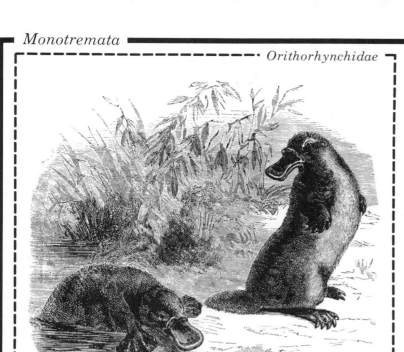

Duck-billed Platypus

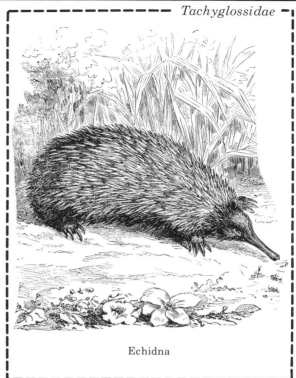

Echidna

Perissodactyla

Equidae

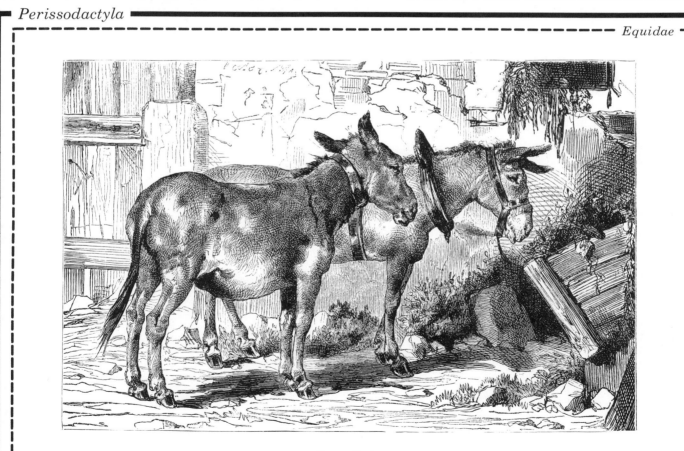

Domestic Ass

Domestic Ass

Wild Ass

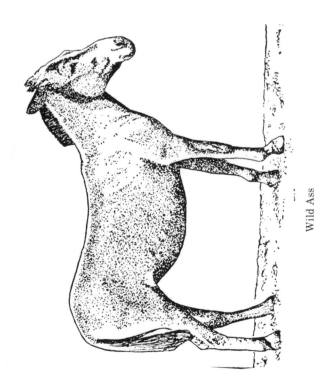

Wild Ass

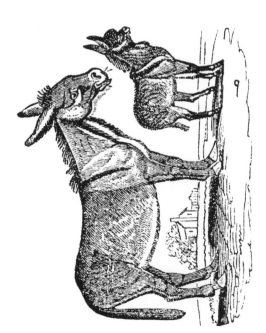

Domestic Ass

Burro

Kiang

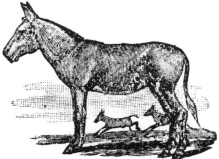

Kiang

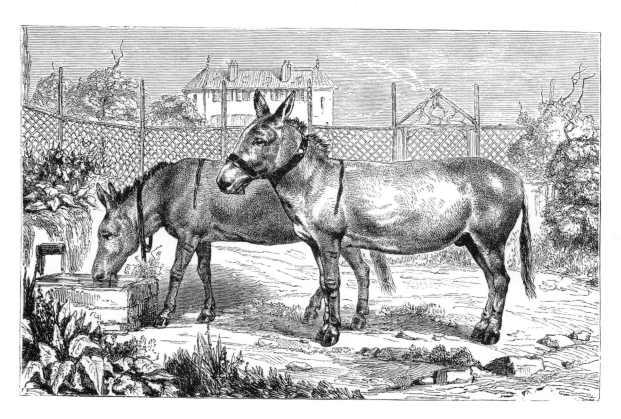

Kiang

Mule

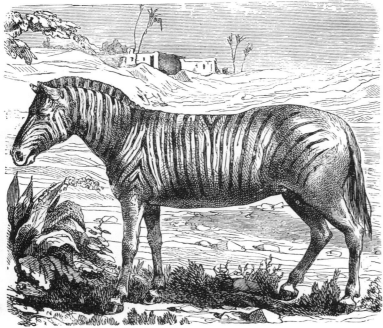

Mule

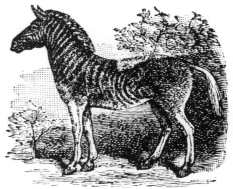

Przewalski's Horse

Quagga

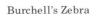

Burchell's Zebra

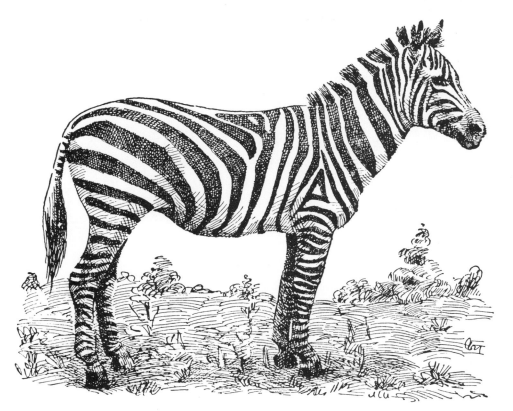

Zebra

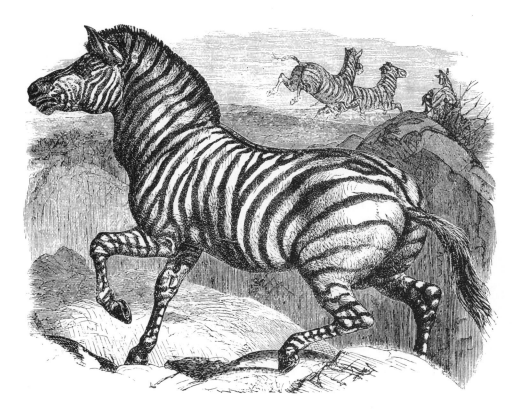

Zebra

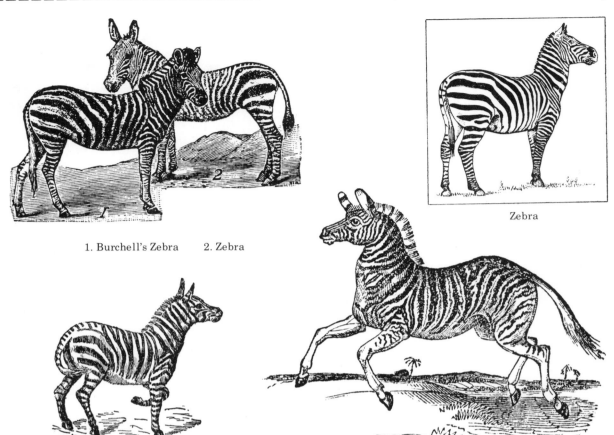

1. Burchell's Zebra 2. Zebra

Zebra

Zebra

Zebra

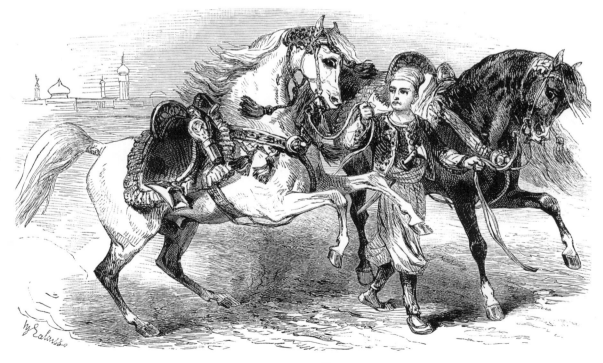

Arabian Horse

Arabian Horse

Belgian

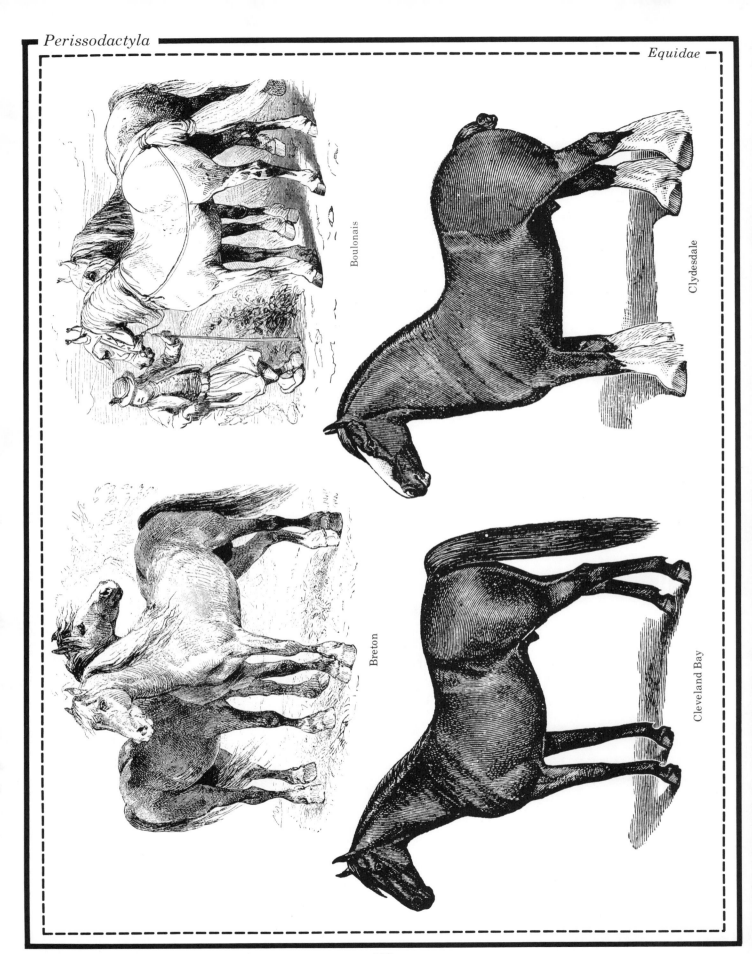

Boulonais

Clydesdale

Breton

Cleveland Bay

Draft Horse

English Race Horse

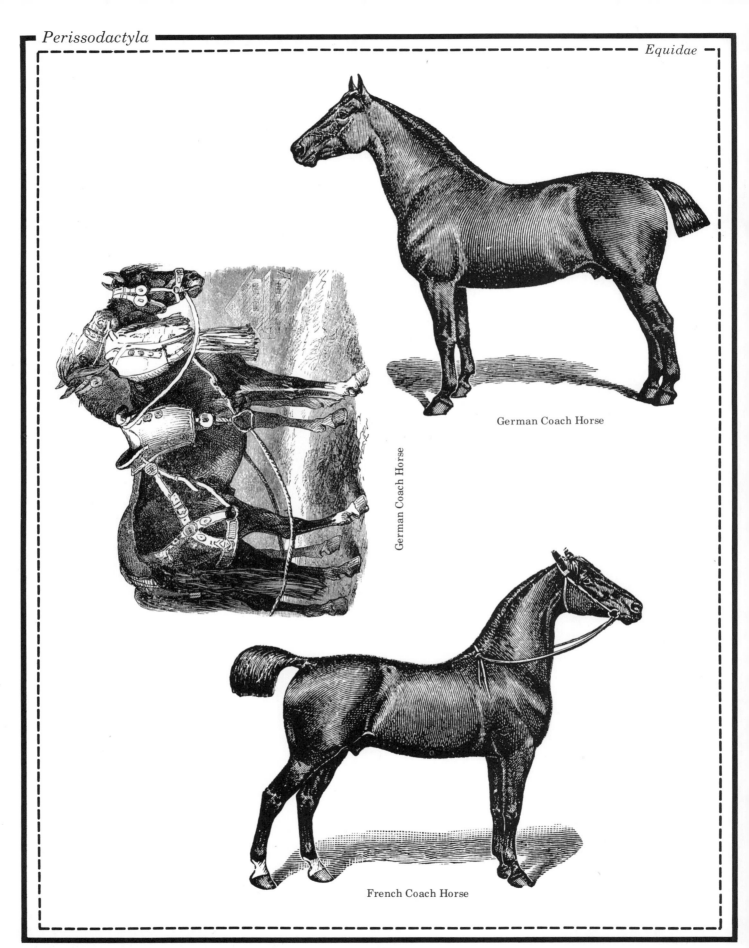

German Coach Horse

German Coach Horse

French Coach Horse

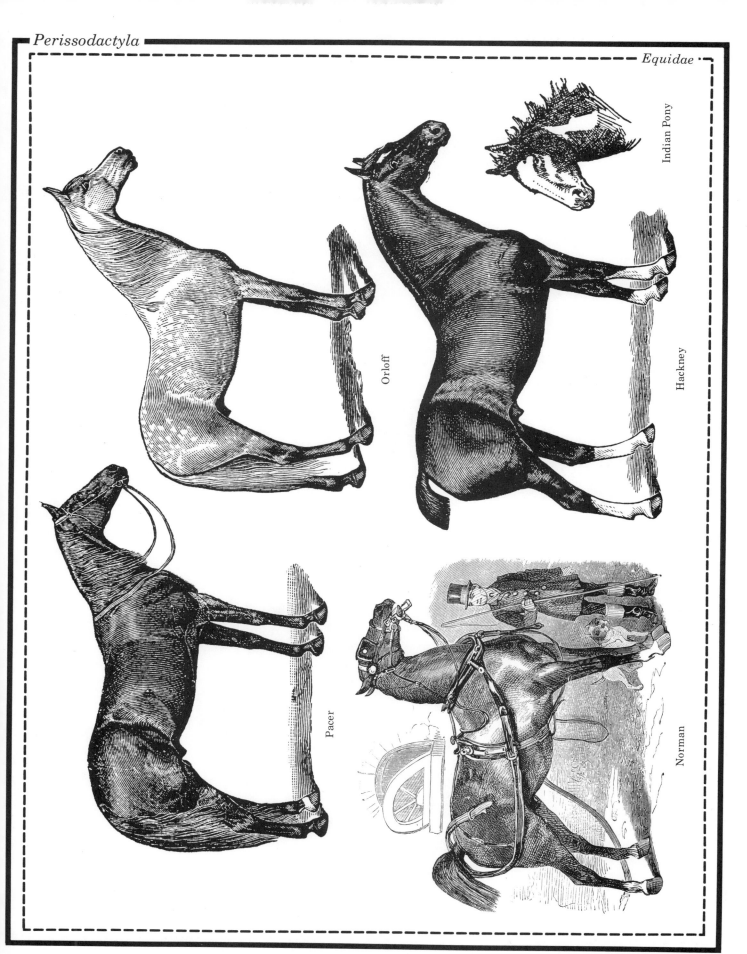

Indian Pony

Orloff

Hackney

Pacer

Norman

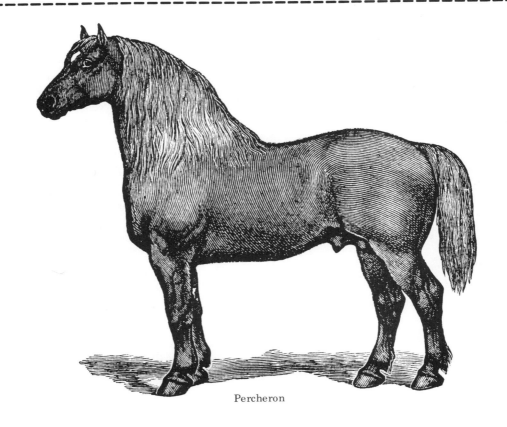

Percheron

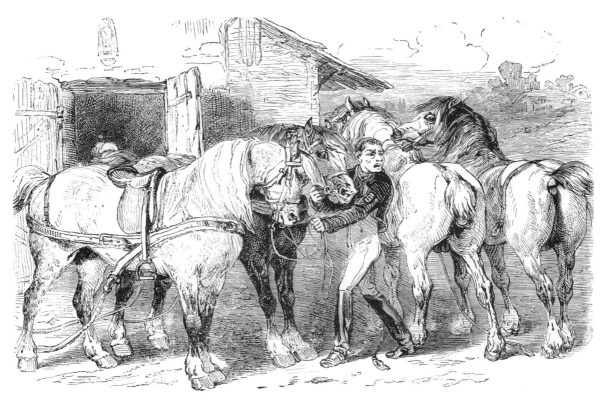

Percheron

Pyrenean

Russian

Shetland Pony

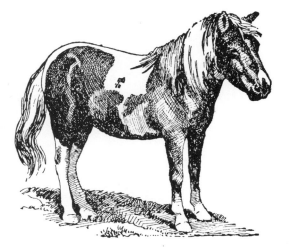

Shetland Pony

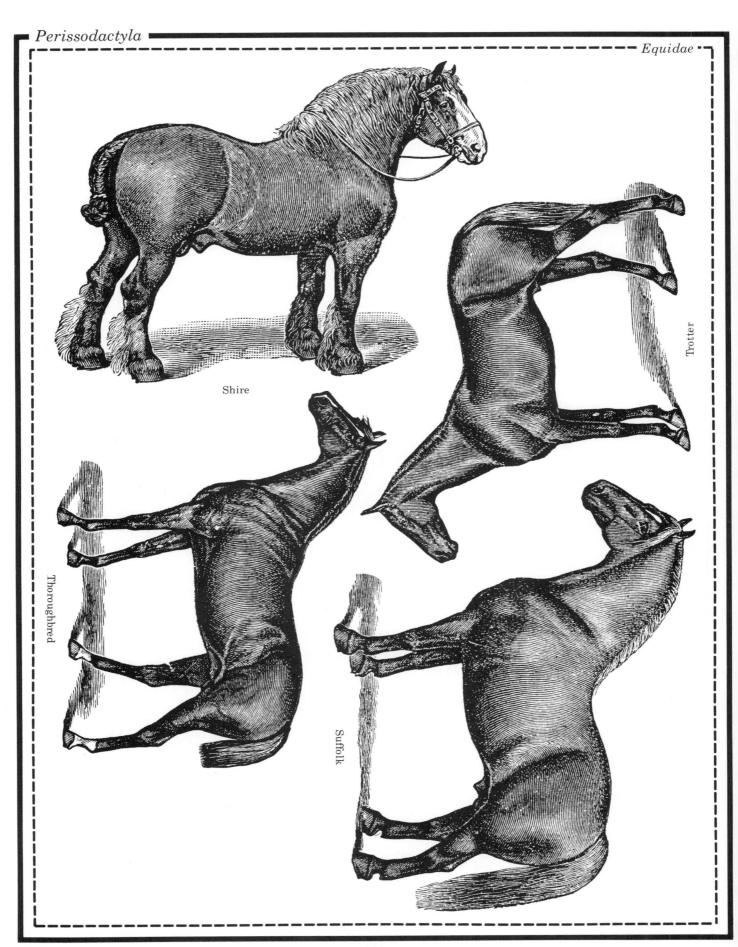

Shire

Trotter

Thoroughbred

Suffolk

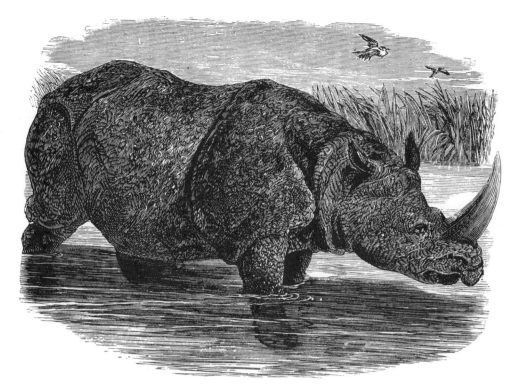

Indian Rhinoceros

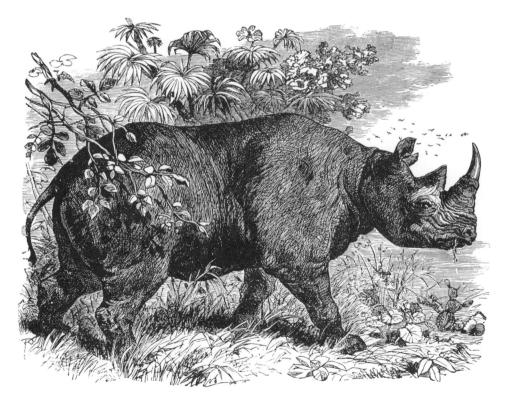

African Rhinoceros

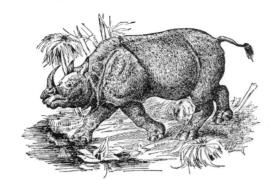

Indian Rhinoceros

Indian Rhinoceros

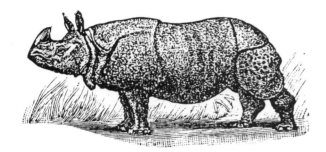

Indian Rhinoceros

Indian Rhinoceros

African Rhinoceros

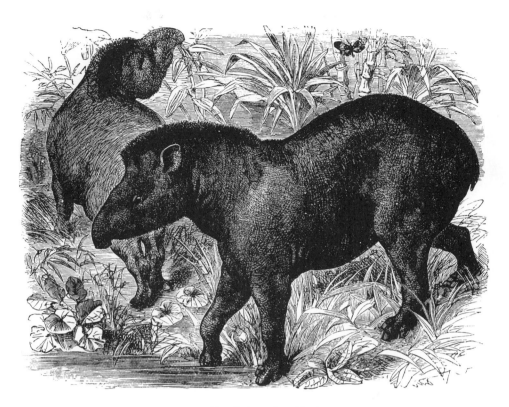

South American Tapir

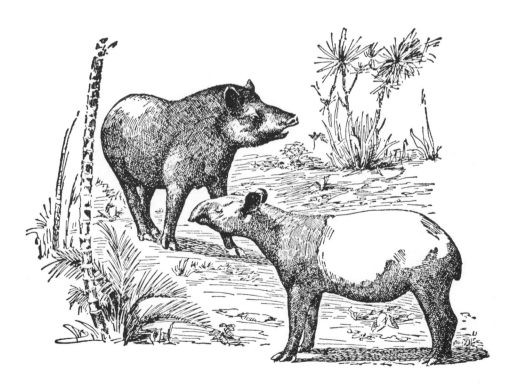

South American Tapir Malayan Tapir

Malayan Tapir

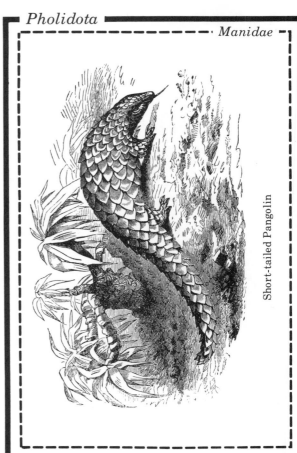

Short-tailed Pangolin

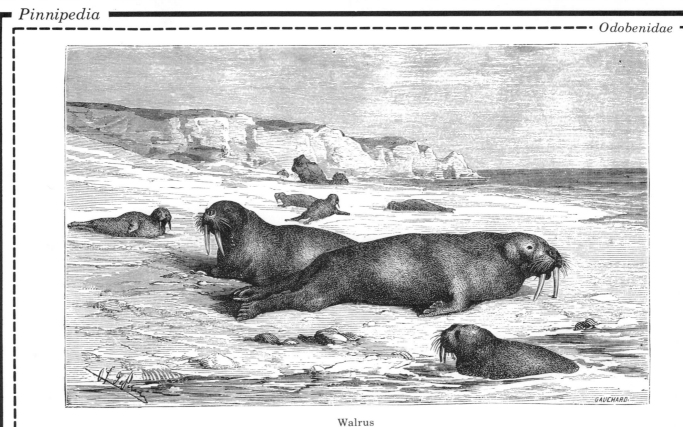

Walrus

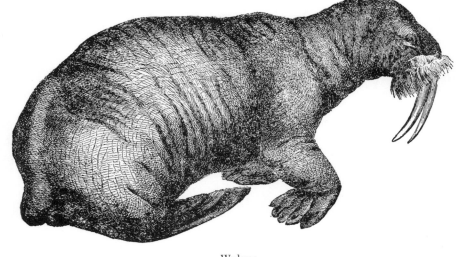

Walrus

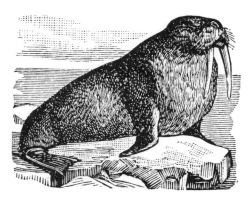

Walrus

Otariidae

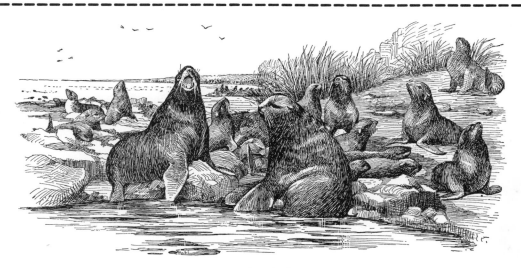

Fur Seal

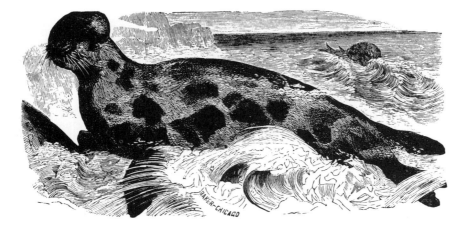

Crested Seal

Fur Seal

Sea Lion

Stellar Sea Lion

Elephant Seal

Harbor Seal

Marmoset

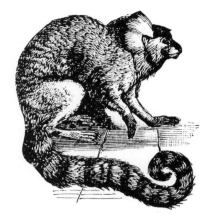

Marmoset

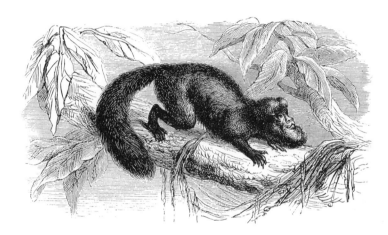

Bearded Saki

Capuchin

Capuchin

Collared Squirrel Monkey

Douroucouli

Monkey

Ouakari

Sapajou

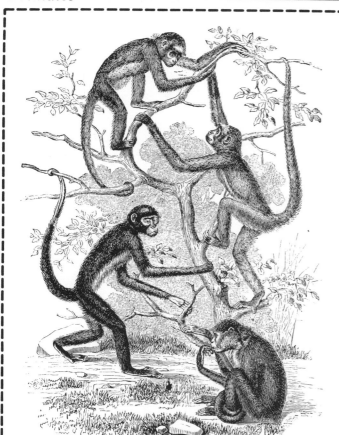

Ursine Howler

Ursine Howler

Spider Monkey

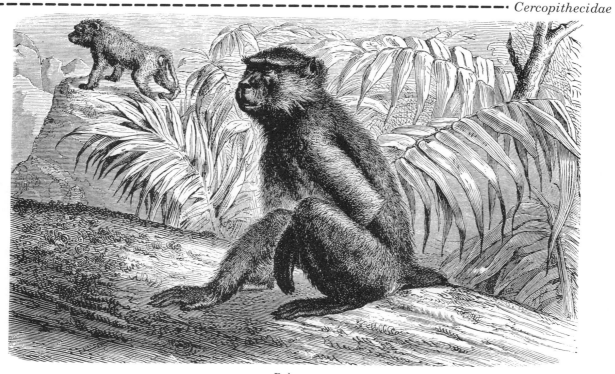

Baboon

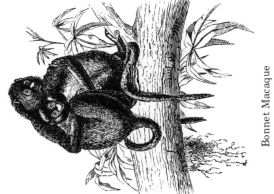

Bonnet Macaque

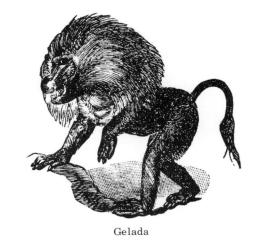

Gelada

Barbary Ape

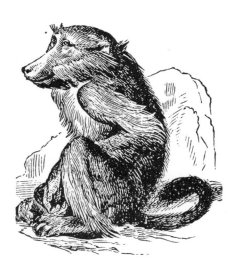

Chacma Baboon

Grivet

Guinea Baboon

Guereza

Lion-tailed Macaque

Hanuman

Mandrill

Mandrill

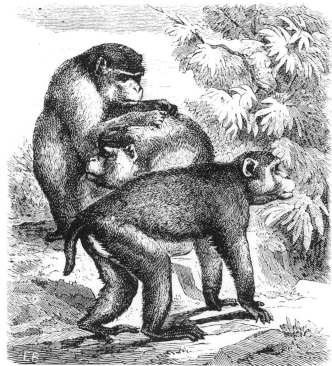

Rhesus

Colobidae

White-nosed Monkey

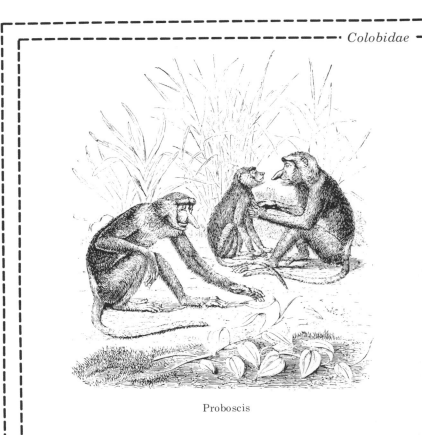

Proboscis

Colobidae

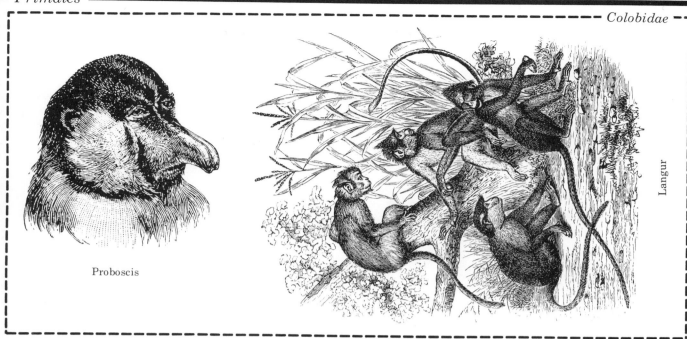

Proboscis

Langur

Daubentoniidae

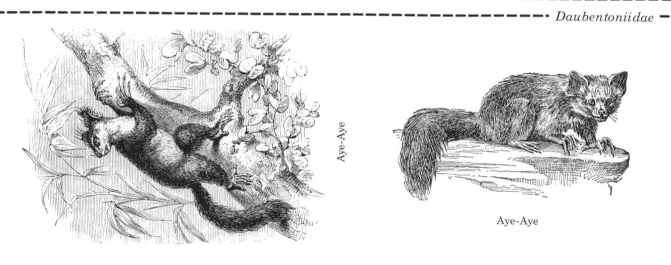

Aye-Aye

Aye-Aye

Lemuroidae

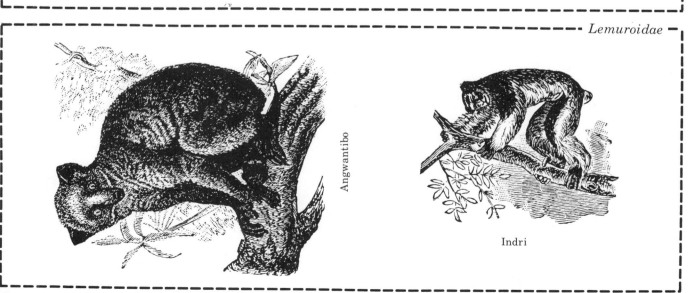

Angwantibo

Indri

129

Colugo

Handed Lemur

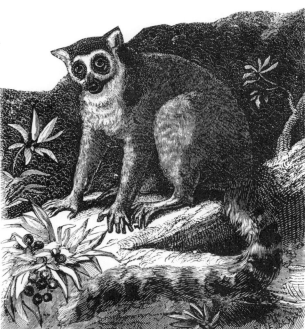

Ring-tailed Lemur

White-footed Lemur

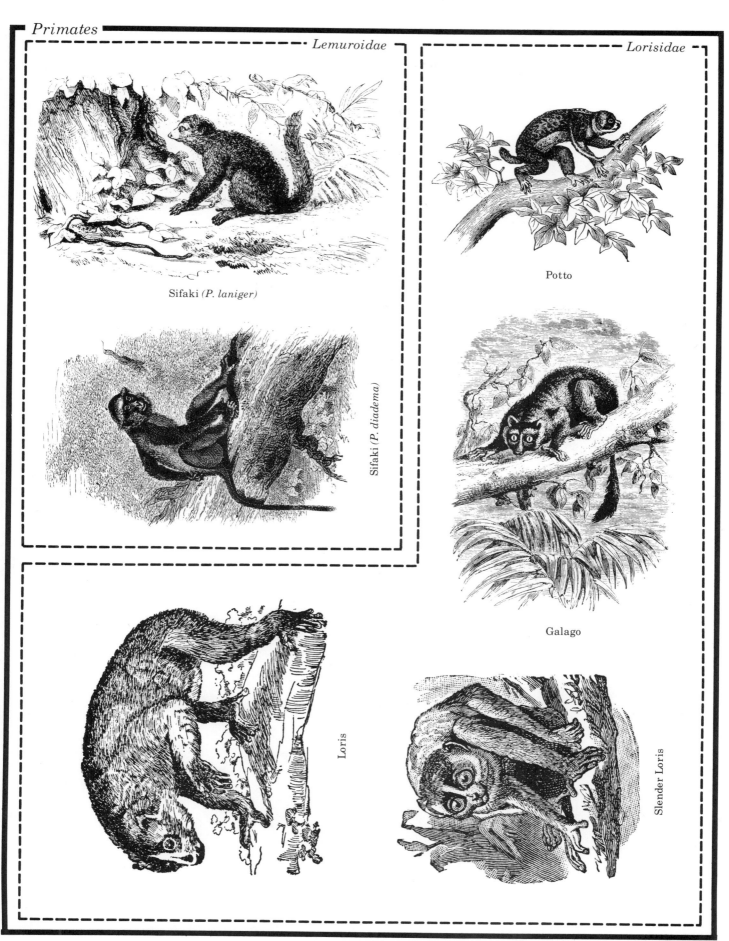

Lemuroidae

Lorisidae

Sifaki *(P. laniger)*

Sifaki *(P. diadema)*

Potto

Galago

Loris

Slender Loris

Chimpanzee

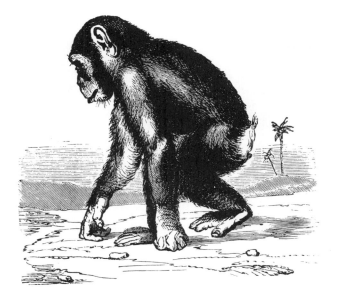

Chimpanzee

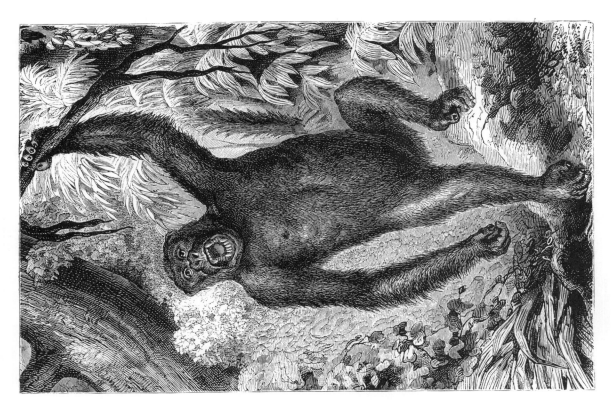

Gorilla

Gorilla hand and foot

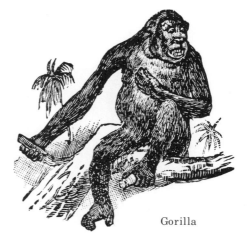

Gorilla

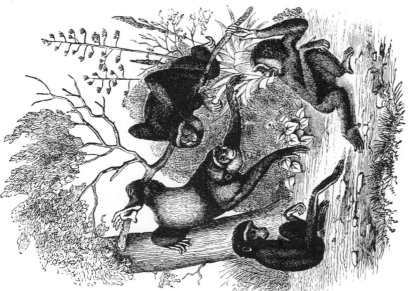

Hoolock

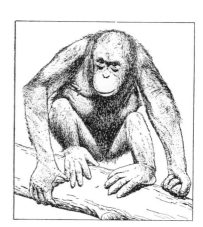

Orangutan

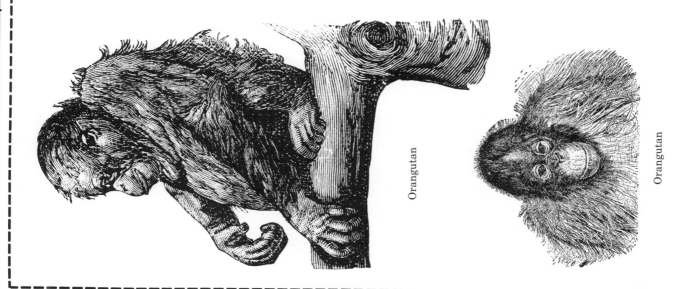

Orangutan

Orangutan

Orangutan

Unga-puti

Siaming

White-handed Gibbon

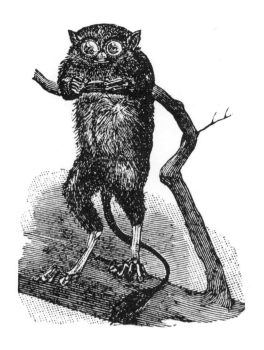

Tarsier

Tarsier

Probiscidea

Elephantidae

African Elephant

African Elephant

African Elephant

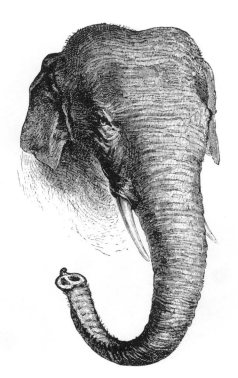

Indian Elephant

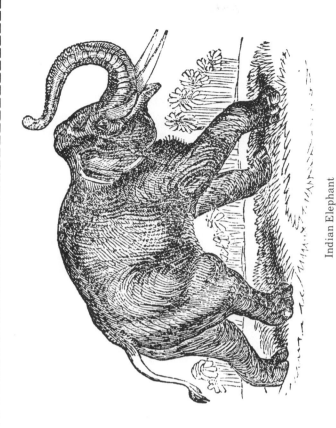

Indian Elephant

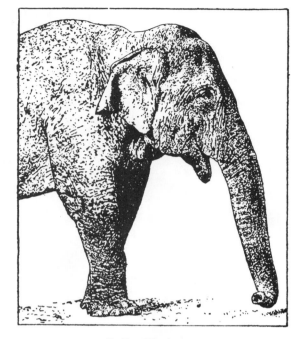

Indian Elephant

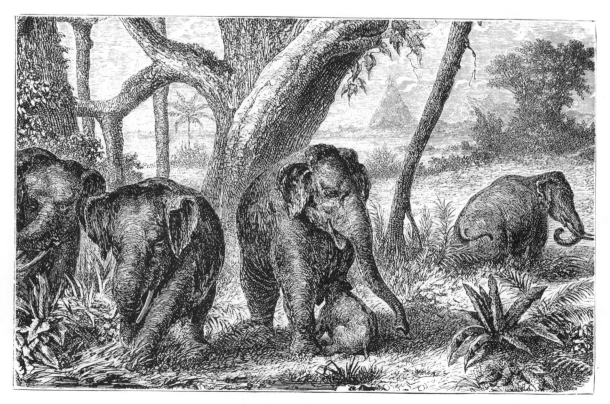

Indian Elephant

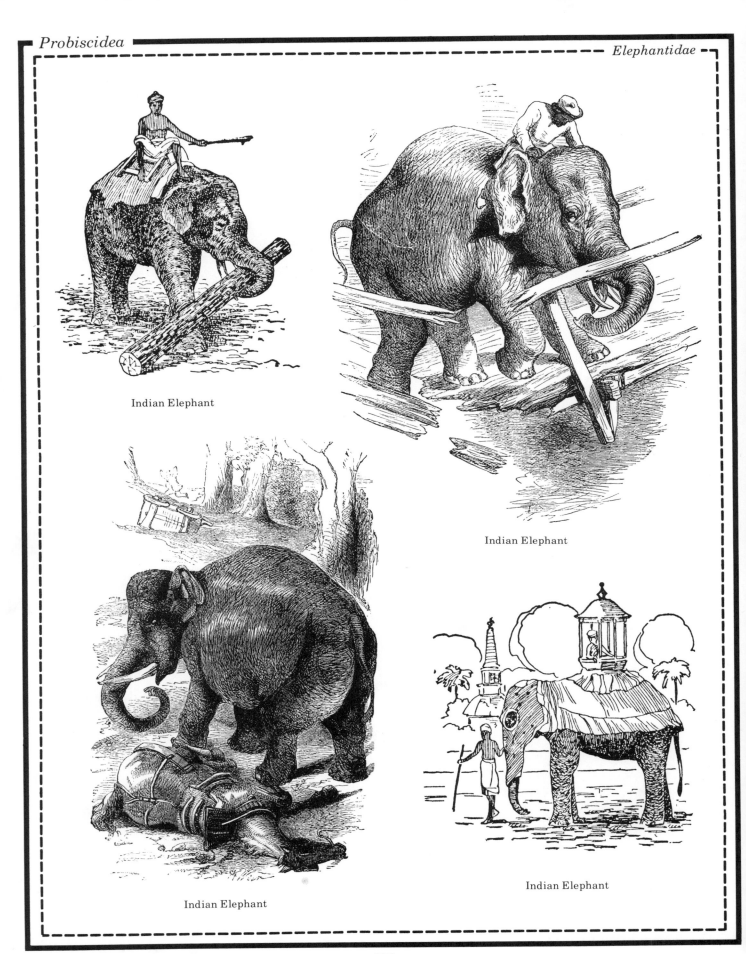

Indian Elephant

Indian Elephant

Indian Elephant

Indian Elephant

Indian Elephant

Indian Elephant

Indian Elephant

Indian Elephant

Rodentia

Anomaluridae

African Flying Squirrel

Capromydae

Coypou

Castoridae

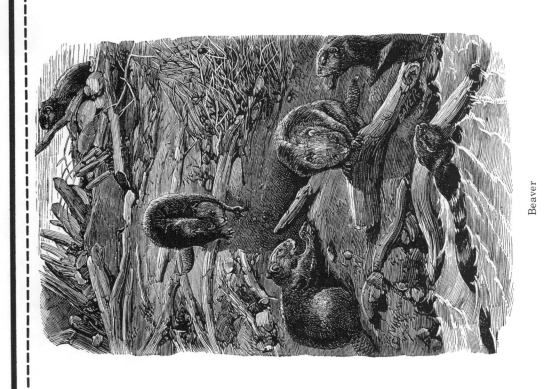

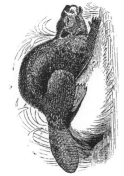

Beaver

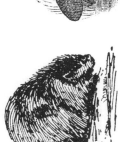

Beaver

Beaver

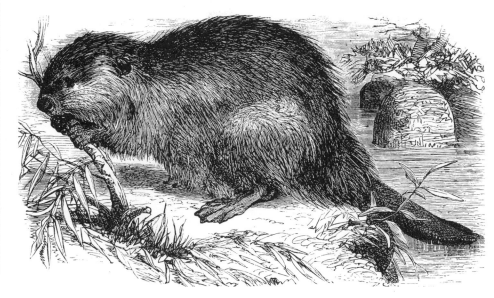

Beaver

Beaver

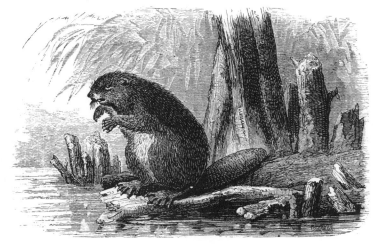

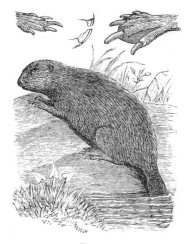

Beaver

Beaver

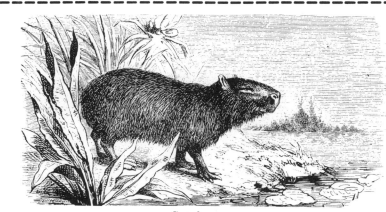

Capybara

Capybara

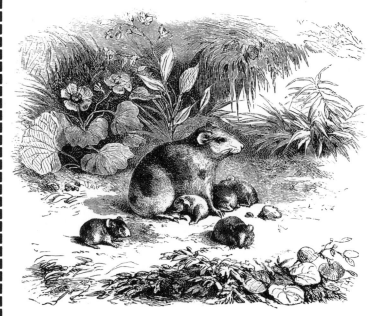

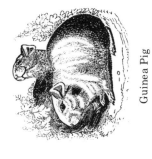

Guinea Pig

Guinea Pig

Capybara

Guinea Pig

Guinea Pig

Chinchilla

Chinchilla

Viscacha

Viscacha

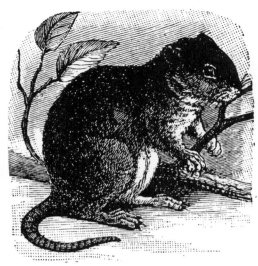

European Field Vole

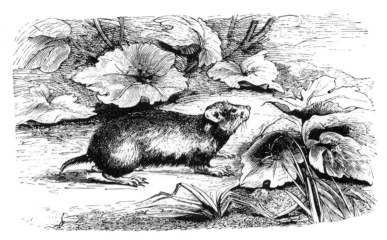

Hamster

Harvest Mouse

Harvest Mouse

Harvest Mouse

Florida Wood Rat

Hudson's Bay Lemming

European Lemming

Meadow Mouse

Lemming

Muskrat

Muskrat

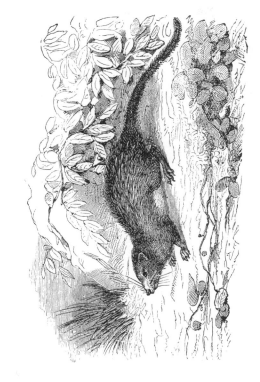

Ctyenomyidae

Tuco-tuco

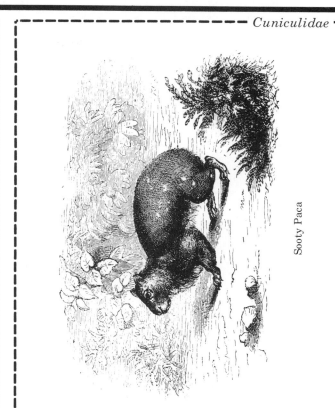

Cuniculidae

Sooty Paca

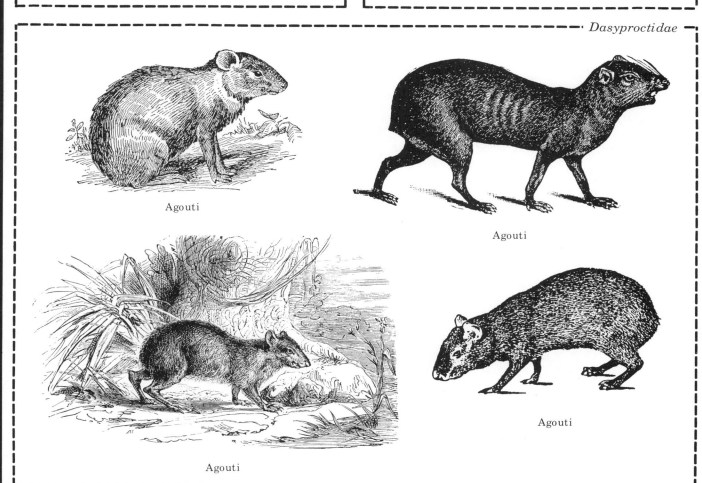

Dasyproctidae

Agouti

Agouti

Agouti

Agouti

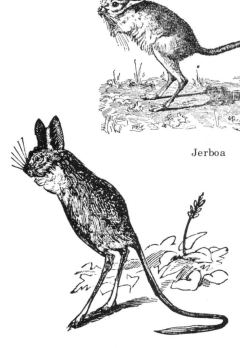

Jerboa

Jerboa

Jerboa

Erethizonidae

Geomyidae

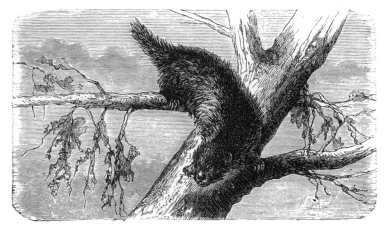

N. American Porcupine

N. American Porcupine

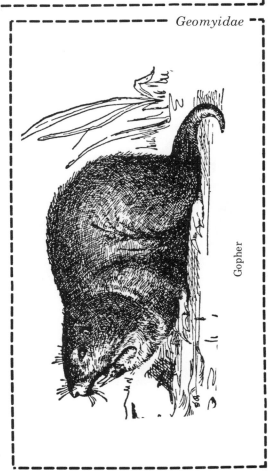

Gopher

Geomyidae

Plains Pocket Gopher

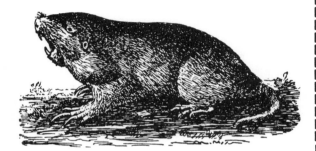

Northern Pocket Gopher

Gliridae

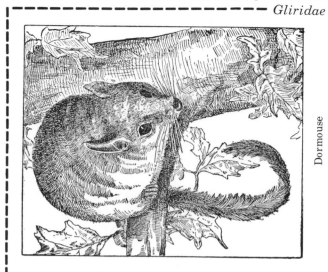

Dormouse

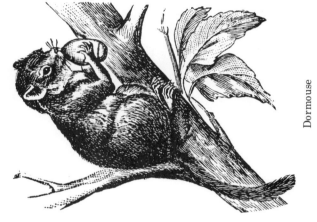

Dormouse

Heteromyidae

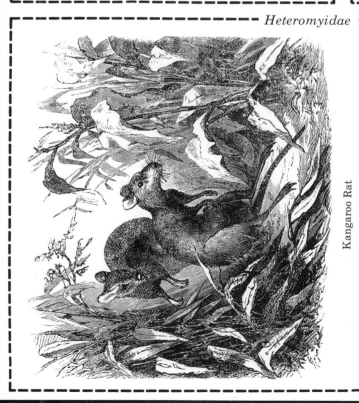

Kangaroo Rat

Hystricidae

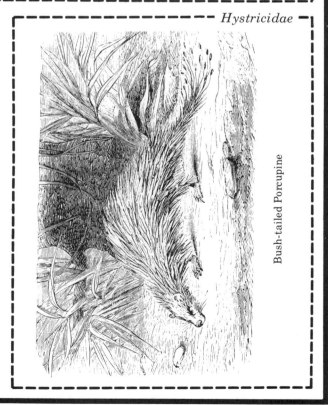

Bush-tailed Porcupine

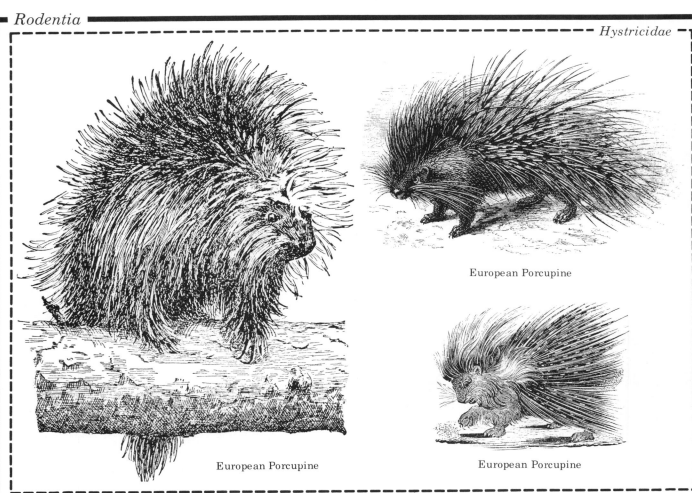

European Porcupine

European Porcupine

European Porcupine

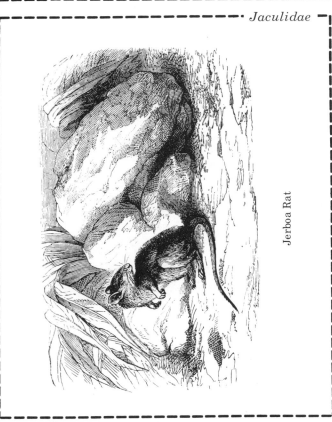

Jerboa Rat

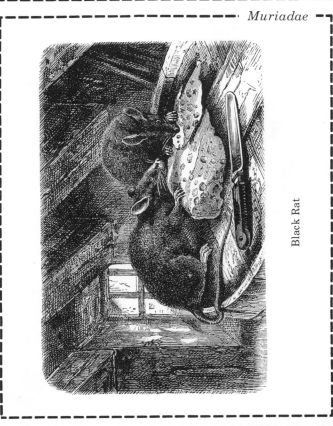

Black Rat

Short-tailed Field Mouse

House Mouse

House Mouse

Norway Rat

Norway Rat

Muriadae

Water Rat

Pouched Rat

Norway Rat

Water Rat

Ochotonidae

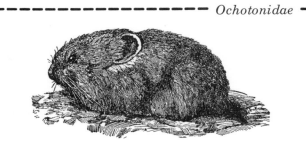

Pika

Peramelidae

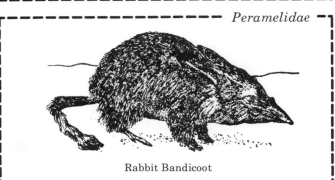

Rabbit Bandicoot

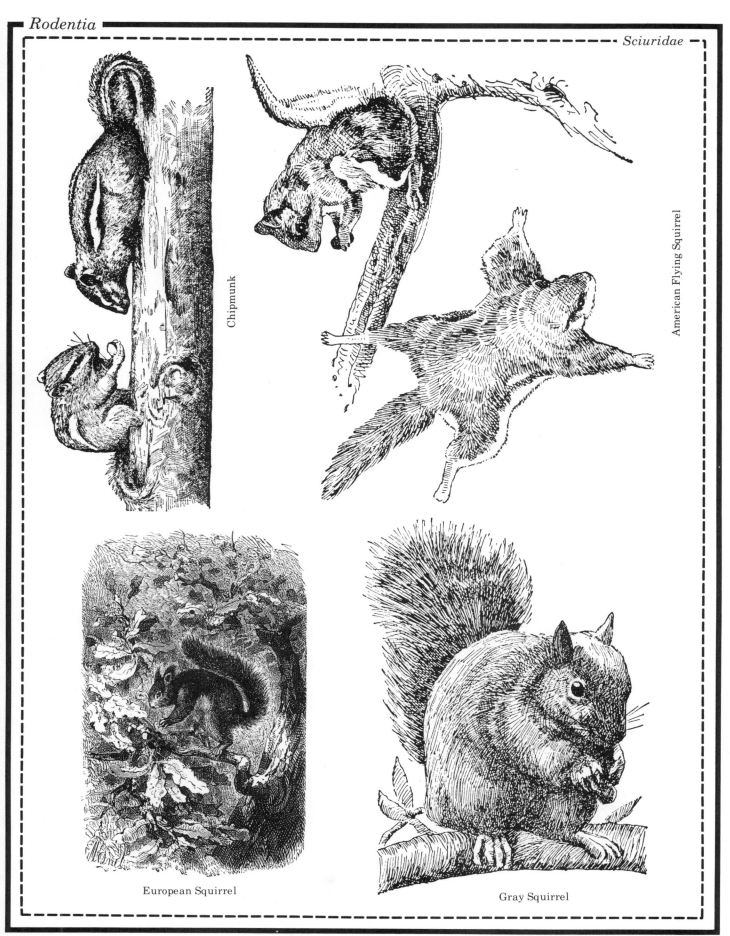

Chipmunk

American Flying Squirrel

European Squirrel

Gray Squirrel

European Squirrel

European Squirrel

Groundhog

Groundhog

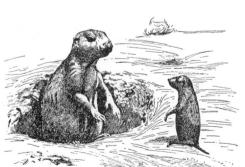

Prairie Dog

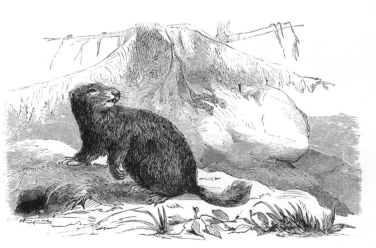

Marmot

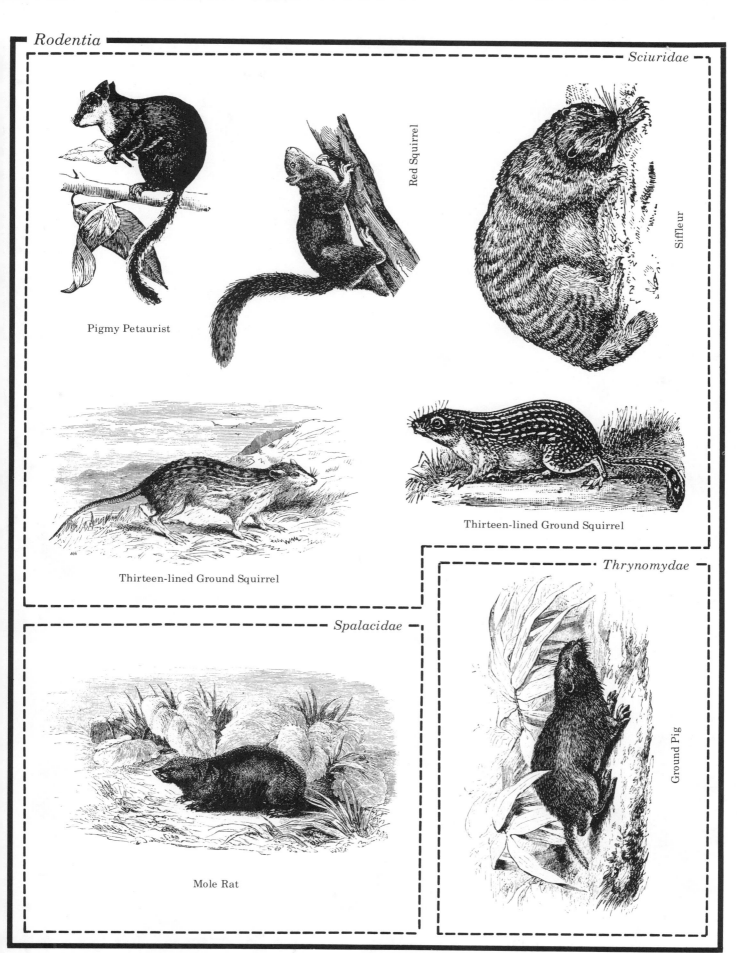

Sciuridae

Red Squirrel

Siffleur

Pigmy Petaurist

Thirteen-lined Ground Squirrel

Thirteen-lined Ground Squirrel

Thrynomydae

Spalacidae

Ground Pig

Mole Rat

Rodentia

Zapodidae

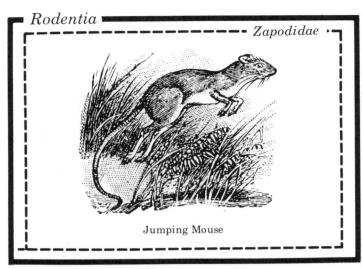

Jumping Mouse

Sirenia

Dugongidae

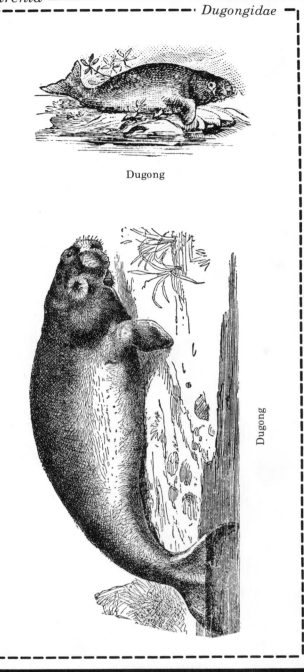

Dugong

Dugong

Trichechidae

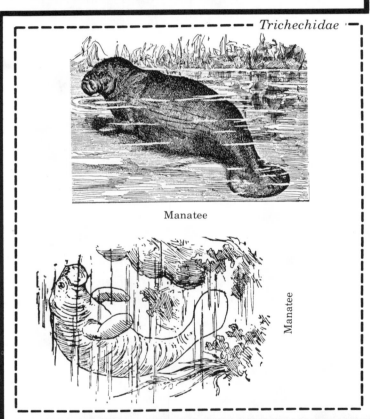

Manatee

Manatee

Tubulidentata

Orycteropodidae

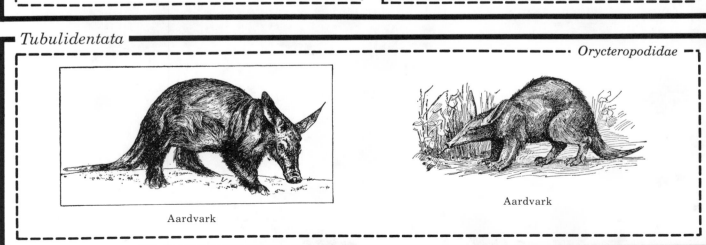

Aardvark

Aardvark

Index